ALIAS OLYMPIA

ALIAS OLYMPIA

A Woman's Search for Manet's Notorious Model & Her Own Desire

EUNICE LIPTON

THAMES AND HUDSON

Copyright © 1992 by Eunice Lipton

First published in Great Britain in 1993
by Thames and Hudson Limited, London
by arrangement with Charles Scribner's Sons, an imprint of Macmillan Publishing Company, USA.

Printed and bound in the United States of America

For my dear redheads

Ken

Carol Z.

&

Linda

Acknowledgments

I am grateful to the following foundations for their assistance and encouragement in the completion of Alias Olympia: *The Rockefeller Foundation, The Ludwig Vogelstein Foundation, The Djerassi Foundation, and the New York Foundation for the Arts.*

Special thanks to my wise, inspiring, sensitive, and persuasive editor at Scribners—my perfect editor—Erika Goldman.

ALIAS OLYMPIA

History of an Encounter

I don't remember when I first saw Victorine Meurent, but I wouldn't have recognized her or known her name at the time. No one would have. She was just another naked woman in a painting. Maybe I remarked that the man who made the picture was called Manet or that the work itself was named *Olympia*, but that would have been it. When I was at college in the late 1950s, works of art were considered things of beauty. Period. One would never pay attention to a painting's literal content. One wouldn't even risk noticing that De Kooning's *Woman II* had a woman in it.

Even as I became a professional art historian in the 1960s, the look of *Olympia* did not change. The naked white woman on the bed seemed like any odalisque, Venus, or Danaë—idealized flesh made into art. I was

taught to appreciate Manet's particularly modern vocabulary, his tonal contrasts, flattened spaces, outlined forms, that is, his fundamentally abstract intentions. It was Manet who was placed first in the pantheon of modernist painting; we were told that before anyone else, he had seen people and events for what they really were: abstract pictorial forms.

But one day in 1970, try as I may, I could not shake the feeling that there was an event unfolding in *Olympia* and that the naked woman was staring quite alarmingly out of the picture. I could not make her recede behind the abstract forms I knew—I had been taught so fervently to believe—were the true content of the work. Her face kept swimming forward, her eyes demanded attention. I saw that unlike other naked women in paintings, Olympia did not drape herself suggestively upon her bed, or supplicate prospective lovers, or droop resignedly. Nor did she smile flirtatiously. Rather she reigned imperiously, reclining upon silken pillows, her steady gaze a dare, her tight little body and proprietary hand an omen. Now I could see that even the stilted pose of the black maid and overarching cat gave the lie to scenarios of seduction. Olympia, alert and dignified, resembled a noble consort on an Etruscan funerary monument far more than an inviting Greek or Oriental courtesan. This was a woman who could say "yes," *or* she could say "no."

Her contemporaries knew this in the nineteenth century though they didn't say it in so many words. In fact, Manet was greatly distressed over how his painting

was received; he even considered destroying it. What happened was this. In May of 1865 *Olympia* was exhibited in the Salon, the official exhibition forum of the time. The press took an instant and bellicose dislike to the work, using words like: "The vicious strangeness of [this] . . . woman of the night"; "a sort of female gorilla, a grotesque. . . ." "Such indecency! . . ." Before anyone knew what was happening, respectable Parisians were sweeping through the Salon's drafty halls brandishing walking sticks and umbrellas; they were heading toward *Olympia* with murder on their minds. The authorities were taken aback, and took the unprecedented step of cordoning off the painting. But the damage was done. Manet fled to Spain thinking: Titian had done it, so had Giorgione and Velazquez—he meant painted naked women—why is everyone so angry at me? This may have been the first time in modern history that a painting incited people to such public agitation.

I discovered that Manet painted the same red-headed woman nine times during the years 1862 to 1874, and from the Metropolitan Museum of Art's catalogue of French painting, I learned that her name was Victorine Meurent. In eight of the works Manet made of her, Meurent examines the viewer with Olympia's unflinching gaze. In the *Déjeuner sur l'herbe* (in the Musée d'Orsay), she sits naked in the country with two clothed men. Canny, unflappable, she peers out, oblivious to the near-pornographic promptings of the story. In *Woman with a Parrot* (in the Metropolitan Museum), neither Meurent's plush, pink dressing gown nor the strange

still-life of parrot and orange distract from the penetration of her look. In *Victorine in the Costume of an Espada* (also at the Metropolitan), her blunt stare and iconic stillness halt the unfolding drama in the bullring.

From each and every canvas I saw that the model surveyed the viewer, resisting centuries of admonition to ingratiate herself. Locked behind her gaze were thoughts, an ego maneuvering. If later on Freud would ask, "What do women want?" then this woman's face answered. You knew what she wanted. Everything. Or rather she wanted, she lacked, nothing. And *that* is why in the spring of 1865 men shook with rage in front of *Olympia*. She was unmanageable; they knew she had to be contained.

These men only meant to persuade her, a single unwieldy woman, to comply. But the plot they hatched, and the map their worries charted, took them way off the road of Art Appreciation and Art History and deep into twentieth-century sexual struggle. Everything was done to silence her. Discourse would bar her presence, indeed would transform her into her opposite—a helpless woman. This is what scholars and writers said about her:

[She] was a young girl whom Manet met by chance in the middle of a crowd in a room at the Palais de Justice. [Théodore Duret, 1902]

Here [in *Olympia*] in the flesh is a girl whom the artist has put on canvas in her youthful, slightly

tarnished nakedness. . . . He has introduced us to Olympia . . . whom we have met in the streets. . . . [Émile Zola, 1867]

[Victorine Meurent] was, between 1862 and 1874, with long eclipses, because she was whimsical, Manet's preferred model. . . . [She was] like a lot of girls of the lower classes who knew they were beautiful and unable to easily resign themselves to misery. She immediately consented to model. . . . [Adolphe Tabarant, 1937]

Victorine Meurent disappeared from circulation for several years and was silent about this disappearance that one knows was for romantic reasons. . . . A sentimental folly had taken her to America. . . . [Tabarant, 1947]

A thin woman with red hair . . . was introduced to me and I was told that she was Marie [Pellegrin]'s intimate friend, and that the two lived together whenever Marie returned to Montmartre. [The red-head] was known as La Glue [sic]; her real name was Victorine. She had sat for Manet's picture of Olympe, but that was many years ago. The face was thinner, but I recognized the red hair and the brown eyes, small eyes set closely, reminding me of little glasses of cognac. . . . She lit cigarette after cigarette, and leaned over Marie with her arm about her shoulder. . . . [George Moore, 1920]

After having attempted, without much success, to give music lessons, [Victorine] tried to paint. She asked for advice . . . from Étienne Leroy, an obscure painter. Soon she thought about exhibiting in the Salon, and the jury was not discriminating. In 1876 she sent them her own portrait and then some historic or anecdotal paintings. Wretched little daubs. [Tabarant, 1921]

[At the café Nouvelles Athènes] going from table to table was a former model of Manet's, Victorine Meurent, nicknamed The Shrimp . . . ; she was showing artists her most recent studies because she had started painting since she was no longer able to pose in the nude. . . . [Georges Rivière, 1931]

[In the] very mediocre salon [of 1879] . . . what a surprise for Manet, that his neighbor in the same room was Victorine Meurent. She was there, smiling, happy, camped in front of her entry, which had brought her such honor, the *Bourgeoise de Nuremberg au XVIe Siècle*. . . . [Tabarant, 1947]

One day [ca. 1895] I was in [Lautrec's] studio and [he] said to me: "Get your cane and your hat, we are going to see '*la*'. . . ." I took my hat and cane, intrigued, and attempted to query Lautrec. He put his finger to his lips and murmured mysteriously. . . . At the end of a quarter hour's walk . . . he darted under the porch of an old house on the rue Douai. He climbed . . . five dark flights of steps and reaching

the attic . . . said to me again, raising his finger, she is more famous than. . . . Finally, he knocked on a little door. An old woman came to open it and Toulouse-Lautrec introduced me to . . . the Olympia of Manet. [Paul Leclercq, 1954]

She tried to sell her drawings to her companions of the night. . . . But she no longer drew very well, and she stopped making them and returned to her guitar playing where she could, and then came the final disgrace. She descended into alcoholism. A painting by Norbert Goeneutte represents her collapsed in a chair against a table on which is located a monkey dressed in red. She grasps in her right hand a guitar and with the other presses down on the neck of a wine bottle. [Tabarant, 1947]

To these writers Victorine Meurent is a wretched lower-class model from the streets of Paris. She is promiscuous and alcoholic; she draws and paints unsuccessfully; she is foolish in her persistence and ambitions. She is a sad, failed person—a loser.

I never saw her that way. Was I missing the point, with all my expensive education? I didn't think so. But how was one to explain the competing images: a pathetic female character on the one hand, Manet's cocky, self-contained model on the other? I wondered why none of the writers were surprised that Meurent—this mere model—painted? Why only condescension and contempt? Why was no one captivated by her trip to the

United States? Why was it designated romantic folly? And what, finally, was behind all the attention this red-headed model received?

I was bewildered and perturbed, and had no idea what to do with these feelings that were so inappropriate to my profession. Art History, after all, promised serenity and pleasure—it's a gentleman's profession—not emotional excess. Luckily I met an extraordinary woman who helped me. Coincidentally she was a red-head, like Victorine, and something of a character as well. She was an art historian named Linda Nochlin. I had already heard of her in the mid-1960s when I was a graduate student. Even then Nochlin was a celebrity although it was not clear exactly what the parameters of her notoriety were. In fact, I sensed something missing in the stories that circulated. The talk was about her unorthodox dissertation, *Gustave Courbet: A Study in Style and Society*, completed in 1963. In it she proposed that the radical politics of Courbet's time emphatically and specifically informed his paintings. The very subjects he chose—an old man and a child breaking stones, the elaborate Catholic burial of a peasant, the portrait of a socialist—and the compositional schema he used had political meaning.

Reading historical events into the style of works of art was forbidden in Art History. This was most stringently the case in the realm of modern art where abstraction, both as visual content and analytic tool, was sacred. Typical thesis subjects in the field of modern Art

History were: "Color in Matisse," "Medieval Sources in Gauguin," "Classical Tendencies in Ingres." But Nochlin drew stylistic considerations into a net of political and social meaning. It was the 1960s. And, it turns out, her Russian-Jewish family had been committed liberals for generations, and she had gone to Vassar, a college noted for encouraging smart girls to speak their minds. She believed in her thoughts; she felt no shyness about her voice. Her prosaic, demystifying questions, her political passions, and her lively, sometimes biting, sometimes poetic prose were harbingers of things to come. Art History was changing.

What was omitted in the gossip about Nochlin I learned when I met her. That happened in the fall of 1970. We were colleagues at Hunter College. She was visiting for the year from Vassar, where she was now a professor of Art History. On the day I saw a striking redheaded woman down the corridor, I walked up to her and introduced myself: "I'm Eunice Lipton, we're colleagues. I'm so happy you're here. I'd love to have dinner with you." Fast. If she was surprised, she didn't show it. "Let's," she said. We made a date for the following week.

Nochlin was taller than I expected, and more girlish. Also less pretty. I assumed that if she was a woman and well-known, she couldn't be "girlish"; who would take her seriously? But because she was a woman she had to be of short to medium stature and pretty. Nochlin was none of these; she moved as if she had a right to.

There also was a querying hesitation, a kind of laughter around her edges, that made her simultaneously accessible and unpredictable.

When the day came for our dinner, I made a list of things to talk about and went to the restaurant. She was waiting. I felt for the list in my pocket.

"How do you like being at Hunter?" I asked.

"I like it," she said. "It's very lively, the students are smart. It is ugly though, isn't it?"

"Yes. Are you commuting?" I knew she had a home in Poughkeepsie. Her face kept turning away, distracted. Or was she shy?

"Yes. Do you like it here?"

"Oh, yes." The coming and going in the city, earning money just for myself having finally left a foolish marriage. I relished the trip to the anonymous Hunter College building on Park Avenue, the smart kids, the colleagues, then back into the city again, home to Barrow Street where I lived alone. A nice big empty bed. I loved it. "I like it a lot."

I thought about the list. "What are you working on?"

"Courbet. Also, I've been thinking about women artists, and why there haven't been any great ones. And if they don't exist and never have, isn't the real question why?"

"Interesting." What a nerve, to just say it like that, no defensiveness, no guilt.

"There *are* no women equivalents," she continued, "for Michelangelo or Rembrandt, Delacroix or Cézanne,

Picasso or Matisse . . . any more than there are black American equivalents for the same. . . . The fault lies not in our stars, our hormones, our menstrual cycles, or our empty internal spaces, but in our institutions and our education. . . ."

"I've been wondering about women, too." I told her what I'd been thinking about *Olympia*. She just kept nodding yes, yes, yes, and looking at me a little surprised. (Dear Linda! Such a mix of Vassar aristocrat and naughty girl, her accent vacillating between haute-Vassar and Flatbush, her eyes so alluring, saying come along, have some fun with me, but then darting nervously away.)

"You should write this up, Eunice," she said offhandedly. She meant publish it. No one had ever suggested that I publish anything.

"They're just ideas, Linda; I haven't done any research yet." She gave me this long look.

"And how many Art Historians have ideas, my dear?" Then I remembered a professor saying to me, "I worry about you, Eunice, you have too many ideas."

I went home and started writing. A few days later I received a poem from Linda in the mail; it was about Matisse and swans.

Nochlin is a mischievous and sexy woman; that's what the gossip in graduate school omitted.

At the same time that I met Linda, another colleague at Hunter made an impression on me. One afternoon I was sitting in the Art Department office and an ex-

11

tremely handsome man in his late forties walked in. No one could miss him—very aristocratic looking, he was: dark hair and beard, high brow, aquiline nose, thin but shapely lips, blue eyes. He was slight of stature, but dignified. We began to chat. I started telling him some thoughts I had about the introductory Art History course we all taught. He looked me over approvingly and invited me for a drink. It had already dawned on me that this man was the most famous person in the department, and a writer I admired. I was thrilled at the prospect of continuing the conversation. We went downstairs to a Chinese restaurant. His brilliant turns of phrase, his dark, brooding eyes tempted me. We talked shop. How to tantalize our lower-middle-class students was a formidable task. Why should they care about art? Of what use was it to them? Just as I was warming to the subject, I noticed that this handsome, intelligent man was finishing my sentences. He had no interest at all in what I might have to say. His own voice alone enchanted him.

"You know," I interrupted, "I've loved your writing, particularly its humility—the knowledge *and* the modesty—but you're really arrogant."

"My dear—Eunice? that's your name, isn't it?—one must be extremely self-assured to be that humble in print."

I can't say when it was exactly that my wonder about Olympia and the treatment she received turned to impatience, but I began to hear the rampaging walk-

ing sticks and umbrellas, and to feel the heat and rage the painting produced in commentators, the barely contained anger squeezed into stylish commentary about artist-geniuses and their pathetic models. I know it was about the same time that I met Linda, and also read an article in the *Village Voice* entitled "The Next Great Moment in History Is Theirs." In it, Vivian Gornick wrote that "women of this country are gathering themselves into a sweat of civil revolt. . . . [Their] energy . . . lies trapped and dormant like a growing tumor, and at its center there is despair, hot, deep, wordless. . . . [They have been] deprived . . . of the right to say 'I' and have it mean something. This understanding . . . underlies the current wave of feminism. It is felt by thousands of women today, it will be felt by millions tomorrow."

The next thing I knew I was throwing Kate Millett's *Sexual Politics* across the room, demanding, "How can this be true, this silencing of women, this enforced invisibility? And what the hell did that professor mean when he said I had too many ideas?"

Then it was August 26, 1970, and a march was called to commemorate the Nineteenth Amendment to the Constitution, the establishing of women's right to vote. I went with my friend Marcia. We made our way to Fifth Avenue and Fifty-ninth Street. As we approached, what we saw took our breath away. Women were everywhere—thousands and thousands and thousands of women. Marcia grabbed my arm and said the oddest thing: "What *would* my mother have made of this?" I

wouldn't have thought of my mother at such a moment. I never thought of my mother as a woman.

But what a sight the avenue was, women filling all the spaces, banishing the cars, the honking, the men. How we gazed upon each other. With what amazement and pleasure we talked and laughed and wept as we flooded that capacious boulevard. And with what confidence we lured the hesitant from the sidelines. How they fell into the arms of the river that we became that day, we women of all shapes, sizes, and ages marveling at each other.

We also handed each other leaflets and flyers that said: "Join the National Organization for Women!" "Come to meetings of Redstockings" ". . . The New York Radical Feminists" ". . . The Feminists!" And we did. We met in churches, in school rooms, in libraries. Then in each other's homes. We organized by neighborhood, ten to twelve in a cadre. We met weekly, and we talked our hearts out. We divulged secrets we didn't know we had. Nothing was off limits. We talked about sex and orgasm, ambition, marriage, homosexuality, our fathers, our siblings, our mothers. The rage at our families, our lovers, our teachers was staggering. And maybe for the first time in our lives, we turned that fury on to the world, away from ourselves.

The listening, the uninterrupted speaking, made us realize how smart we were, and how inhibited. For most of us, this talking—this consciousness-raising—was the first time we heard each other speaking discursively and analytically about our lives. Bit by little bit, our talking,

our weeping, and our anger added up to an emotional and political history. And a strategy.

What better emblem for the time—those opening salvos of the Women's Movement—than *Olympia*, a woman whose naked body said: "See this? It's mine. I will not be the object of your gaze, invisible to my own. This is my body, my life."

Yes, I marveled at the intricate psychological drama surrounding *Olympia*, which on the one hand elicited men's attraction—so many had written *some*thing about her at a time when models were usually nameless and invisible—but on the other provoked ridicule and contempt. *All that writing about her.* In our own time, in 1977, an entire book on *Olympia* written by Theodore Reff, and again in 1985, T. J. Clark, the most dazzling bad boy in the Art History community, published a notably long, obfuscating, and tortured essay on *Olympia* in his book on Manet. Every prominent scholar of nineteenth-century art planted himself in front of her, writing paraphernalia at hand. All thought their engagement disinterested, but it wasn't. They circled her from above, close up, on top. What did they mean to do with all those words? Describe her? Analyze her? Situate her? *Or:* Possess her? Control her? Silence her? No one admitted his emotions, neither the irritation nor the fascination. None could acknowledge what amounted to a professional obsession that spanned a century and a half. And continues.

More and more I brought Meurent up in my classes

as if I could somehow redress the balance by at least speaking her name, acknowledging her corporeality as Victorine Meurent, a real woman of the nineteenth century. Musingly, I'd say, "Some day I'm going to find this woman," and the more I said it, the more I meant it. It became a promise. I took her to myself, unconsciously, unwittingly. That face, those eyes. I wanted what she had: her confidence, her dignity, her "no."

Many things came between us though. My career for one, books and articles about geniuses—Picasso, Degas, Manet. And my own ambivalent self stuck in a conservative profession. And a culture that enjoined girls to behave themselves. Plus—I rationalized—all I know is Meurent's name, that she worked for Manet, traveled to the United States, exhibited a few times at the Paris Salon. She was only a model. What is there really to say?

I had no idea what the ramifications of the search would be. I didn't even realize that our names were the same: "Eunice" is a translation from the Greek of "Evnike"; it means "Happy Victory." And I certainly didn't *intend* to end up a redhead. All I knew was that I envied Meurent her autonomy even as I acknowledged the paradox that I was a well-paid American professor in the late twentieth century, and she a working-class model in nineteenth-century Paris. I was convinced that she had had more choices than I, and that she had acted on them. The dare of her gaze was the proof.

As I set out in earnest to find Meurent, I kept losing my way. A two-step of desire and longing crossed by

withdrawal and passivity. I had learned this dance as a child, but coming of age in the era of McCarthyism, Eisenhower, and Doris Day refined it immeasurably. Across this faraway history I started looking for Meurent.

This is the record of my search.

My mama told me ...

City College was a perfect place to stifle desire in the 1950s. It was also a perfect place to dream. It was the school so proud of its past leftist tradition, especially those men and women in the Abraham Lincoln Brigade who marched off in such high spirits only to die in Spain in 1936. My own uncle David, my father's brother, had been one of them. And many of us were red-diaper babies, although our parents had thrown up their hands in despair, shattered by the Stalin-Hitler Pact in '39 or the disclosures about Stalin in the fifties. Disillusion came to my mother when the American Communist Party expelled Earl Browder in 1946. She said, "If they can throw you out just for having a different opinion, it's like religion: you're in if you agree, out if you don't. No thank you. I'm leaving!" My father, never one for

commitment, gave up even the pretense of caring for anyone besides himself when his brother died.

For many of us, City's leftist political history was our apologia for being there and not at some Ivy League school. But I don't think we could have gotten into those other schools. I couldn't have. It never entered my mind, anyway. So, there we were at City in the fifties, passive *and* contemptuous, ready to either fall asleep on our feet, *or* spout grandiosely about Plato. We were even afraid to sign petitions; our own parents told us not to! They for whom the protests of the labor movement had been so important. Now they said, Be careful. Remember McCarthy. Remember the Holocaust. Betrayal is everywhere. You could die just because you're Jewish. Nothing, they said, is worth dying for if they could kill you for being Jewish. What could we say? It almost seemed as if that's why Ethel and Julius Rosenberg were electrocuted. And what a sadness that had been, the two of them lying there, side by side in their coffins, so pale, so humiliated.

So, we went to school, we studied, and we worried. Worrying was very important. We were The Young Existentialists and The Hopeful Analysands; Sartre and Freud were holy men to us.

We whiled away our afternoons in the South Campus cafeteria, an unremittingly dreary and cavernous room half underground, half above ground. If sunlight ever penetrated the huge gray windows, it was always in the distance, dappling someone else's shoulder; it never touched you. Someone always sat down next to

you, and most of the time you didn't notice what sex they were. White coffee mug in hand, maybe a book, a notebook and pencil, and the conversation ran like this:

"So what are you doing?"

"Nothing."

"Have you seen *La Dolce Vita*?"

"No, not yet."

"Great movie."

"Yeah?"

Everyone sat hunched over, avoiding each other's eyes. You can't imagine the body contortions. It's hard to believe that these bodies were between seventeen and twenty-one years old.

It was the 1950s, and we were poor and chaste, and we sublimated furiously. We found corners in our small, crowded apartments, and half hours on the train to school; often we'd sit in movie houses alone. We spun our fantasies into gold. There was a sense of equality among us then, boys and girls alike. I think it was the neutering that made us equal, even in the eyes of our professors. The fact is that no matter what the 1950s are known for, at City we were not playing house. I knew no one who resembled Jimmy Stewart or June Allyson.

We had no idea why we were so sluggish, why we felt so doomed and sad, so woefully dragged down. It wasn't any of our faults, really, or even just our parents' faults, although ultimately—and for years—we blamed ourselves and them on analysts' couches all over New York City, maybe all over the world. We were over-weight and sexless, and we slept a lot. We went for blood

tests—our families thought we were anemic—but we were depressed, and the doctors didn't know it. It wasn't the right decade for depression.

We were a miserable, lonesome bunch, and we were stingy. We didn't encourage each other, we weren't kind. If anyone ever wants to picture us, Giacometti's phantom figures in *City Square* and Camus's anesthetized victims in *The Plague* would do perfectly. In our own peculiar way we touched each other, but it wasn't a question of liking, just like*ness*. We didn't like each other.

We toiled long hours in the library, sitting alone or together at narrow tables. It seemed as if we'd be there forever, which was okay; we were learning. It was the most important thing we'd ever done. We read, and dreamed. We wrote with enormous effort, as if the words didn't belong to us. How hard writing was for each of us was a gauge of how serious we were. The longer it took you to write and the more anguished you were doing it, the smarter everyone thought you were. Providing, of course, you produced something.

Everything hung on the writing. Everything. You'd get chest pains if it wasn't going right, you couldn't walk, you couldn't sleep, you were constantly in a state of nausea. And all we were working on were little three-page essays on Marvell and Chaucer, or maybe Browning, one of those enchanting poems about the Renaissance and Christianity and Italy. I particularly loved the one about the coveting prelate ordering his far-too-lovely tomb:

And so, about this tomb of mine. I fought
With tooth and nail to save my niche, ye know—

I was astounded that a bishop could have sons at all,
let alone bribe them from his deathbed:

And if ye find . . . Ah God, I know not, I! . . .
Bedded in store of rotten fig-leaves soft,
And corded up in a tight olive-frail,
Some lump, ah God, of *lapus lazuli*,
Big as a Jew's head cut off at the nape,
Blue as a vein o'er the Madonna's breast . . .
Sons, all have I bequeathed you, villas, all,
That brave Frascati villa with its bath,
So, let the blue lump poise between my knees,
Like God the Father's globe on both his hands. . . .

—a vain and silly bishop blaspheming even as he dies.
And to children of the Holocaust? And yet with what
poetry did this petty man long for his niche and his
pleasures.

We knew at City that just a generation earlier people
had gone to our college for important reasons, for po-
litical reasons. We knew about the Communist cells and
Spain. *We knew*. And we were sick of this knowledge and
ashamed that we didn't care. We wanted the poems, the
music of that nineteenth-century language as foreign to
our ears as our parents' Eastern European accents were
familiar. We wanted the pleasure of those words. And
the shelter.

So, the political irrelevance of our subjects did not diminish our desperation. We were all aware that for our atheist but Jewish families, leaving a book on a library shelf with our name on it was the greatest success we could attain. No greater *nachas* could come to your family. From the age of seven, I knew that being a writer was the very apex of desire.

I remember afternoons at college, dragging myself home to write, the house empty, chilly; my teenage brother David still at school. At the door stood my mother's bookshelf filled with titles like Howard Fast's *Citizen Tom Paine*, Sinclair Lewis's *It Can't Happen Here*, Joseph Roth's *Job*, John Dos Passos's *U.S.A.*, all strangers to me, beloved by her but oddly never spoken of. By the time I reached my room—a mere few steps beyond her books—my body sagged with fatigue. "I'll just lie down for a while," I'd say to myself. I'd doze fitfully, wake with a start, sweating and anxious, filled with rage toward everybody but especially toward my mother. She didn't want me to write; she didn't want me to do anything. I was sure of it.

She'd come home from work at five-thirty—she was a bookkeeper in the fur district—and brush past me, hardly noticing. For supper she'd make me and David meat cooked to some shade of gray in the portable broiler and vegetables rendered lifeless by the pressure cooker. In the evening she'd sit in the kitchen with her girlfriends just on the other side of a cardboard divider from my desk. Every day I'd ask her not to do this— "Ma, I'm trying to work"—but she'd forget. And there

they'd sit and smoke, talk and laugh and drink coffee. I'd hear nuts cracking and candy dishes sliding along the table top, and "Can you believe what's going on in Mississippi? Those Negroes really have guts"; or "My goddamn husband. . . ."; or, "You should've seen the *drek* on sale at Klein's." Sometimes, I became so irate that I'd slam into the room and scream at her right in front of her friends, "Why can't you let me work? How many times do I have to ask you? Why are you sitting here when you could just as easily be sitting in the living room?" She'd look up stunned. What had *she* done? She'd make excuses to her friends, and they'd leave. Then she stammered something about *her* life and *her* friends. She'd sit down in the kitchen again and stay there long into the night, smoking cigarettes and drinking coffee. I didn't care.

And if my father, Louis, happened to be around, he didn't take her part. His daughter was studying. Couldn't Trudy see that? My mother.

What a life those two had together—their two bodies scarcely touching yet electric. Her pajamas forever torn. His gray eyes sliding over her contemptuously; her dark ones turned away. They met when she was fifteen, he eighteen. Now, she stammered in his presence, gone the blustery Trudy her girlfriends knew. The more she hesitated, the more he went after her. We'd be having supper, and he'd sneer, "Trudy, where'd you hear that? From one of your smart friends? You never know what you're talking about, Trudy. You're so stupid. And you're fat," he'd spit out. She just sat there, silently. But if you

listened, you could hear her reeling herself in, way, way back into her own private hiding places. He wasn't going to get her. Nobody was.

My brother said nothing—a thirteen-year-old sunk down behind his glasses and his adolescent woes. I was on my father's side. I couldn't stand my mother—her flabby body, her stammering, her taking it. Louis told me I was the smart one. Still, I worried. I'd cry, "Daddy, I'm afraid I'm going to be like her." He said, "*Maydeleh*, you'll never be like her. You're smart, *maydeleh*."

It was the passivity I was worrying about. Also, people said we looked alike.

I had a deep yearning in the days I was at City, a longing I associated with the walk in front of our apartment building on Riverside Drive, far up near the George Washington Bridge; we'd moved there from the Bronx when I was thirteen. In my memory, it is always a fall day, and I'm leaning into the wind, and dreaming of a sweet man who loves me, who looks at me caringly and touches my face. Often, I'm walking with my father. I put my arm through his and he talks about the old country—Riga—and how beautiful it was. How wonderful the Opera House was, how bright and elegant and warm. How he'd rush there after working in his parents' delicatessen where he'd never eat the sweets because he had so much self-control. And how you had to bundle up to go to the opera—it was always winter in his stories—and afterwards come home to the samovar. He ridiculed my mother; he told me about his girlfriends.

When I was a little girl, Louis spent a lot of time with his third-string hoodlum buddies, guys with names like Izzy, Lazar, Harry, Al. They played cards for days on end and filled the house with clinking coins and schnapps glasses, thick masculine voices and the smell of cigars. Louis had been a prizefighter when he was in his teens, a fancy dresser and an outstanding dancer. I don't even know if he finished high school. At fifteen, he must have rolled off the boat delivering him from Riga via Liverpool to New York harbor right into some gym in the Bronx. He became the kind of boy you had to be to make it with the other guys. He forgot about the Opera House, the samovar, and home. He almost forgot. But the fact is, nostalgia made Louis run, and it made him mean. Trudy never lived up to his delusions. *He* was from cosmopolitan Riga; *her* family was from a *shtetl* near Lublin. What could *she* know about anything? He despised her. How could he have married her, he wondered?

Louis was full of stories about the past, but always disappearing on you in the present. He'd be there, with his little mustache and natty suits, eyes sparkling; he'd tell you a great story, and the next minute he was gone, and you'd never know when you'd see him again. I'd hear he was with his pals in Miami or Cuba. He loved jai-alai and the horses. God only knows where he got his money. He also told me terrible stories about little girls being sold by their brothers in Havana. Every time he'd leave the house I'd get these strange tremors up my back, starting real low down. He'd kiss me good-bye,

and then I'd dash into another room. I'd wait till I knew he was just out the door, and then I'd run feverishly after him to give him a second kiss.

I was left in the apartment with Trudy, in the bare rooms in which we circled each other. I'd try to work; she'd interrupt me; she always interrupted me. I couldn't shut the door on her. It made me frantic.

Louis respected me because I was verbal and suspicious. Respect was the most important thing in my house. To earn it you had to be fast on your feet. A rule was, if there was any possibility of making a mistake, you didn't try something, you kept your mouth shut, because the worst thing that could happen was that you'd be laughed at. I became an expert at sniffing out potential humiliation. I stopped playing the piano for my father after the first time I scrambled a few notes and heard him moving restlessly in his chair. Words were an easier place to negotiate. Words were flexible. You could put them together one way, rearrange them another. You could just keep moving, smiling, gesturing. With the piano, you either played the right notes, or you didn't. I stuck to words.

If outright desire was hard to come by at City, we had our escapes. Movies, for example, and literature. I loved Dostoyevsky and Hardy. The completeness of their landscapes enthralled me—the everlasting snow and exhilarating cold in one, the yellow fields and bustling markets in the other. I also associated Dostoyevsky with

a girl I admired at City. She had large breasts and a melancholy boyfriend whom she was always with, and whom you just knew she slept with. One day she came to history class with dark shadows under her eyes. People said she'd stayed up all night to read *The Idiot*.

It was the women I loved in Hardy. They seemed—Tess and Sue Bridehead in particular—so there, so particular, so full. They were inscrutable, they kept their own counsel, and they were intelligent. You could hear them thinking. And they were against marriage. The ferocity of restraint between the men and the women, and then their capitulation gripped me. I loved Hardy, too, because of my father. Hardy was the first author I gave my father.

We always talked about books, Louis and me. He prided himself on his love and knowledge of Russian literature. The litany went something like this: Why don't you read a little Lermontov, Eunice? How about some Chekhov? Have you read Pushkin's *Eugene Onegin* yet? No? Have you got something in store for you! Gorky's *Mother* nearly broke my heart, but you're too young for that. Finally, of course it was Tolstoy and Dostoyevsky, and Turgenev. For my father, however, Dostoyevsky was it. As far as he was concerned, a person's character depended on whether he read—and loved—Dostoyevsky or not.

Louis and I would go out for walks and muse about Ibsen. Or we'd go ice-skating and over hot chocolate fall to wondering about Vronsky or Alyosha. Sometimes, as I grew up, we'd go to the opera—usually Puccini or

Verdi—and at intermission, it was books we turned to. What a romance we had, my father and me. It was Louis who said, Eunice, go to Europe. He also said, Eunice, don't get married.

Louis and I also went to the movies together. Often we'd meet on weekday afternoons at a favorite theater, one that specialized in foreign films. My father was forever involved in some mysterious business that left him free in the afternoons. We'd cozy down in the theater's darkness and wait for the French or Italian words to start. And when they did, we were gone. New York just went away. I guess he was off to Riga or more likely some New York fantasy about money, power, and women. For me, it was a vaguer longing, a kind of love sorrow.

Many years later, I heard that before I was born, Trudy wanted to leave Louis. His disappearing the way he did, the other women, the nastiness. His own brother, the one who later died in Spain, urged her to do it: "Louis's a mean man, a weak man, Trudy. Get out while you can." Then she went and asked her mother, who said, "Trudl, you made your bed, now you have to sleep in it." Trudy didn't leave Louis. She left her children.

When I was three my mother took me to my father's parents, who owned a roominghouse in a little town called Hurleyville in upstate New York. It was quiet in the car as we drove. My mother was wearing a nice suit and a pretty hat. She was smoking. I got sick to my stomach a couple of times. When we arrived, Grandma

and Grandpa were standing by the fence as if they'd been there for a long time. My mother picked me up out of the car, and hugged me. She gave Grandma my suitcase, and Grandma took my hand.

When I looked up, my mother was gone.

Years later, Trudy told me she had to leave. "It was wartime and your father was working in the shipyards; I had to take care of his candy store." Another time when I asked why she left, she said her mother had just died, and she was depressed and couldn't take care of me. But the fact is, my mother left my brother, David, when he was the same age. No war was going on, and her mother was long dead.

Whatever her reasons, when she got in the car and drove away, she broke my heart, and I never forgave her.

Of all my flights from City, fantasies about Paris were the best. Everybody loved Paris. As a kid in the Bronx I'd hear my father, or my grandparents—his parents—sighing when they said "Paris" as Bizet's *Carmen* blared on 78s in the background. They remembered cobbled streets and graceful balconies, the river Seine, and the lovers. I don't think any of them had actually been to Paris. At City, Baudelaire's name was pronounced but few read him. We knew Zola's *Germinal*, and also *L'Assommoir*, and Balzac's *Cousin Bette*, and of course Degas's ballet dancers and Renoir's courting couples. Paris was a place where everyone wanted to go.

So, at City, all our passions were pressed into the

words we read, the words we tried to write, the movies we escaped to, and dreams of Paris. We never spoke these words to each other. What could one do in the late 1950s with all the rules and regulations about sex and politics? There was nothing to do, so we marched fervently inward, clutching our novels, our sadness, and our rage.

In my senior year I fell in love with, and married, a rich and miserable Jewish boy with a Harvard education. I had hardly dated, and the next thing I knew I was getting married. No one thought it was a goal of mine, least of all me. It didn't go with the cafeteria at City, although a lot of girls were getting married. It was expected. I must have known that. Even if it didn't fit, not with Hardy and Dostoyevsky and all those dreams. But as Shulamith Firestone wrote in 1970, "Women live for love." And that was true whether you considered yourself special or not, or whether your father respected you or not. And if you thought you had escaped your mother, you were wrong.

So I married Jake and moved into an apartment a block away from my parents. Jake was a gentle, shy person, lonely and unknowing about women except from books by Hemingway and Fitzgerald. He was short, dark-skinned and dark-haired, with a slim, agile body. He looked beautiful on a tennis court; he was a pleasure to look at running for a bus. Jake loved literature and seemed to be a good writer although he couldn't get himself to do it much. He drank a lot and relished the company of his male friends, who were a mixture of

Jews and Gentiles the likes of which I'd never known. They were also very rich except for one, who was very poor and in their eyes the most manly. He had a gorgeous Cuban girlfriend and had chosen Harvard over the Yankee baseball club. Even in my fear and trembling at the power and disdain of those rich boys, I could tell a taste for life *à la* Hemingway when I saw it.

All Jake's friends had girlfriends, but you knew that the guys liked each other best. They would play cards and drink late into the night at somebody's parents' house in the country. Or sometimes they'd all stay in Cambridge, and go off to a men's bar and I would be left behind with my aching pride and girls who made me feel old-fashioned and lonely. They all seemed to be accepting things as they were. Maybe I looked like I was doing the same.

The biggest appetite I had was for words, and these guys shut me up entirely. They scared me. They were so confident. They'd all gone to Harvard, and they thought Art History was stupid. They thought many things were stupid.

Jake wanted me, he called and wrote me nice letters, he was sensitive and gentle, and he had class. His musing and sadness touched me and made me feel safe. He was smart, too—I mean, he'd gone to Harvard and some Gentile prep school—and I think somewhere I wanted company, rather like what my father had provided. I thought we'd talk about books. And he was a writer, he said.

Years later, feminists would say about those pre–

Women's Movement days: "Women marry the men they want to be." Let's say I wanted to be a writer and didn't know it. Although I'd won a short-story contest in the third grade and was very proud of it, I did not grow up saying, "I'm going to be a writer." At the High School of Music and Art, where I went to school, I took no special writing or literature classes. They were filled with rich kids from Riverdale, or so I thought. Maybe I didn't have the confidence to join. At college I was a history major who took a lot of literature courses, but something told me that becoming a writer was impossible, that I could not tell my immigrant parents, or myself, that that's what I wanted in life. Such *nachas*— a book on a shelf—couldn't come from a girl. It was understood. So, I took to talking instead. I became a professor. It was more manageable. In a way, I followed in my father's footsteps. For among his many jobs, selling was the one he was best at and enjoyed the most. First it was costume jewelry and Christmas lights at the farmers' markets on Long Island, then appliances and furniture on Gun Hill Road in the Bronx. At the end, he had his own furniture store in Manhattan. My father was a seductive man; he could sell you anything. Teaching is a lot like that.

Five years after we were married and were living in Rhode Island, where I was teaching at the university, Jake began to say he didn't love me. The first time he said it, I ran off to a museum to bury myself in paintings, and to call my father.

"What's wrong?" Louis asked.

"I don't know, Dad. The only thing I can think of is that I ask him to help with the dishes sometimes."

"Get a dishwasher. Don't bother him."

Don't bother him? My father was saying this to me? My father, who thought I was so smart? I shouldn't bother him? I, who was earning the only salary in the house and doing all the housekeeping, *I should stop bothering him?* What was my father talking about?

Oh, yeah, Jake was trying to write. I stopped bothering him. I started hating him instead.

A few months later Jake again said he no longer loved me. I threw the suitcases on the bed. He grew flush and adamant, assuring me that if I left, nobody would hire me.

"You can't quit your job in mid-year. It will be the end of your career. You'll ruin your reputation."

"*What* reputation, *what* career?" I screamed. "I'm twenty-five years old, for Christ's sake!" I might have added, "and only a girl."

I left for New York. It was 1967.

I landed in Manhattan and headed to a friend's house on Eighth Street. I found adjunct teaching in a couple of colleges for almost no money, but enough to support myself, buy books and the occasional clothing extravagance for falling in love. I was only twenty-five and I'd never fucked anyone but Jake. I had no idea what men saw when they looked at me, but I noticed them looking. Did I seem sad with what one Milanese boy years ago had called my Madonna Dolorosa look? Or

was it that too-intense energy that forgot everything when I talked about something that interested me? Men always bewildered me and made me feel watchful and a little sick. I thought they hated me, but wanted something I couldn't put my finger on. I never knew what was in it for me, but I knew I needed them for something. I liked the chase, and I really got into the fucking once I got the knack. I was beginning to feel very beautiful. It was at this time that I learned one of the most important lessons of my life.

I found a sweet apartment on Barrow Street in Greenwich Village. It was an early-nineteenth-century building, a charming, dilapidated three-storey affair with a garden at its center and ten tiny apartments surrounding it. I had one medium-sized room with a precipitously slanting floor, three windows facing the garden, a fireplace and a tiny bathroom with a half-sized tub, a mini refrigerator on top of which was a two-burner electric hotplate. For some reason I never discovered, the apartment came replete with a large bottle of Chivas Regal and the most beautiful green velvet dressing gown I'd ever seen.

It also came with a neighbor who scared the wits out of me, but about whom I was curious. He was a Rumanian named John, about six foot three and very muscular. We nodded at the mailboxes in the narrow, tunnel-like passageway leading to the garden. Often I had the impression that he rubbed up against me, maybe accidentally. It made me uncomfortable, but I didn't know what to say. I had the feeling he knew exactly how

many visitors I had in my room, and what I did with them. One day, he invited me to have a drink in his apartment. I accepted.

Trying to be cool, I sat down. He said, "Look, I want to help you. You've never had an orgasm, have you?"

Where, in God's name, did this animal come off asking me such a question? "No, I haven't."

"Well, I can help," he said.

I'm sure you can, you beast. "Oh, how's that?"

"There are three things you can do. I can bring you to orgasm; I'll just do something mechanical to get you there—don't worry, nothing romantic. Or you can go to a lesbian; I can call someone. Or you can do it to yourself."

"Uh-huh. Well, thank you very much for your, uh, concern," I said, searching for the completely appropriate response. "Have to be going. Got a date." He smiled.

Home. Shut the door and the lights. Pull down the shades. Take the phone off the hook.

My mother never told me.

Ten months after my mother left me in Hurleyville with my grandparents, she came back. She kneeled in the grass, smiling, her arms spread wide. She waited for me to come to her. All those many months with Grandma and Grandpa—the winter nights together in their bed, the snow, white and silent outside, Grandma singing Russian lullabys, Grandpa taking me everywhere in his brown car. My mother gone. I can still feel

the mean smile that twisted my face that day as I looked at her kneeling there, and let her go forever.

She shrugged, "She'll come round, she's my daughter. I'm her mother." It never happened. Things got worse and worse between us. I was stubborn, so was she. I didn't like to do things her way. She started hitting me; I was five years old. She threw me in a closet and tied me up. Nobody stopped her. Nobody knew. But I was a smart kid. I was as smart as I was desperate, and I knew Trudy's desperation. I knew she longed for me. She couldn't comprehend my hatred, the venom that poured from my eyes, my heart. What had she done to deserve this? When she hit me, I kicked her; when she smacked, I cursed. Each time it escalated until I spit at her, and she pushed me away.

That was our embrace, my mother's and mine. A hopeless emptying of our hearts. Never forgiving, always longing.

It was 1970 when Victorine's face came into focus for the first time. Unsmiling and serene, she looked at the world with desire. She could go anywhere. I took her hand.

Voilà Victorine

*I*t was a good fifteen years before I embarked on my search for Meurent's life, but in the mid-1980s I went to Paris for six months and began. It was a casual inquiry, at first. So much so that I didn't know I was looking for her precisely. The book I had come to work on was called "Both Sides of the Easel: Women as Models, Women as Artists." It was going to be about Berthe Morisot, Mary Cassatt, Suzanne Valadon, and Victorine Meurent, four women who had been painters as well as models for other artists. I was fascinated by this mixture of traits—that on the one hand each woman coveted the conventionally masculine persona of artist, but on the other, each agreed to the typically feminine role of object. Women traditionally were models and muses, wives and mothers, not artists and geniuses. I

thought it would be fascinating to watch two such competing impulses in the same woman and in women of different classes.

Morisot (1841–1895) was an obvious choice, despite the fact that I didn't much like her work. She was an ambitious artist and a beautiful woman whom Manet relished painting. Like the other Impressionists, she specialized in domestic and bucolic scenes, but her style was instantly distinguishable by its long brushstroke, her taste for white, and her preference for images of women and children. Her accomplishment—both as an artist and as a participant within the Impressionist group—combined with her having in Eugène Manet, the famous Édouard's brother, an adoring, supportive husband made her attractive to me. She was also a wealthy woman, which cast an interesting light on the question of ambition.

Manet made a number of extraordinary paintings of Morisot during the late 1860s and early 1870s, one of which is *Berthe Morisot with a Bunch of Violets*. In it the artist portrays a disheveled thirty-one-year-old Morisot averting her gaze from the viewer. Her somnolent black eyes and tenderly pursed pink lips intrude upon the eggshell delicacy of her face with the most delicate affection. She is as sexy as an unmade bed, simultaneously sheathed and adorned by the deep and decorative blacks of her garments: a tumble-down black hat perches on her straying auburn hair; a black scarf caresses her throat; a black coat sits gently on her shoulders.

A love portrait if ever there was one. And typical of

Manet's pictures of Morisot. She is always represented by him as a beautiful woman languishing on couches or gazing melancholically out at the viewer.

Cassatt (1845–1926) appealed to me more than Morisot because I really enjoyed her work. She, too, was a rich *and* ambitious woman involved with the Impressionist group, and she chose to model for Degas on a number of occasions. I admired Cassatt's blunt and elegant adaptation of Japanese prints, and I savored her edginess and wit, her obstreperous children squirming and misbehaving, the trenchant looks of her matronly women. Sometimes—and outrageously—Cassatt silences her feminine sitters by ironically placing teacups and letters over their mouths (*Five O'clock Tea* and *The Letter*). Her rambunctious imagination attracted me.

Degas liked to draw Cassatt at her dressmaker's and milliner's, gazing in a mirror, turning this way and that to admire a hat, being fitted for a dress. Twice he drew her stylish silhouette in rapt attention in the Louvre. Both depictions, as laconic and witty as Degas can be, show Cassatt engaged in passive and typically feminine pastimes. Only once, in *Miss Cassatt Holding Cards*, did he evoke an abrupt and inquisitive woman.

From the start my interest was most piqued by Valadon and Meurent, perhaps because I identified with them the most. Valadon (1867–1938), whispered at the edges of Art History, shut away like a madwoman in the attic; writers liked her less than Morisot and Cassatt. She was a favorite model of Puvis de Chavannes,

Toulouse-Lautrec, and Renoir, all of whom painted her naked, dancing and waiting—a winsome, seductive girl full of sensuous appetite.

Valadon was a remarkable artist who looked at the underside of life. She drew and painted the sexual awakenings of children, and female nudes that are so awkward and self-contained that they dare the viewer to find his usual pleasures there. Her portraits and still-lifes are positively iconic in their stillness and concentration. I was extremely curious about how this lower-class woman handled her two personae.

Finally, there was Meurent, the most famous face and body of the nineteenth century, painted by Manet, and perhaps by Alfred Stevens, Puvis, and Degas as well. And she was also an artist, although no one had ever laid eyes on her paintings.

A realization that may well have been the catalyst for "Both Sides of the Easel" was the fact that although all four women entered the profession of artist, none were ever depicted working, even by their male artist friends, whereas the men loved to paint each other painting. Examples include Frederic Bazille's *Studio on the rue de la Condamine*, Renoir's *Monet Painting in His Garden at Argenteuil*, Manet's *Monet Working on His Boat in Argenteuil*, and Gauguin's *Portrait of Vincent van Gogh*. This omission said: History will turn a blind eye to aberrant desire.

When I heard from an acquaintance who served on a grant-giving committee that I would receive a large grant for the following year to work on "Both Sides of

the Easel," I gave myself permission in the remaining months I had in Paris to focus on Meurent. It was an impulsive decision. I said to myself, "Look, so little is known about her, just go ahead and get all the research done now. You'll be back next year to work on the real book." But I never got the grant, and I chucked Cassatt and Morisot. I had to admit, finally, that, however fascinated and outraged I was by their predicaments, their wealth and privilege bored me. Valadon was intriguing, but I knew a smart woman who was already working on her. Meurent was to be my subject.

Even now as I write her name, she draws me into a state of wonder and reverie. She looks at me wistfully and brushes the hair from my face. She whispers in my ear and hints at marvelous discoveries. She smiles. Then, straightening up a bit she says, half tease, half entreaty, "Find me, Eunice." How, Victorine?

Will I follow you down the street a hundred years after the fact? Find out where you lived and climb your staircase, touch the walls you touched, imagine you? Must I turn Paris into the site of my unconscious and play it, free-association-style, as if I were lying on a psychiatrist's couch? Or will it be more tawdry still, like the night a dark young man and I picked each other out on Broadway, prowled the street up and down until moving closer we looked into each other's cold eyes, and walked back to my apartment?

Victorine tells me of a party in a house set back behind a wall. She says it starts late. I make my way to the designated neighborhood. The trees, gate, silence

have all the markings of wealth—where Morisot might live, or Natalie Barney, but not Meurent. I reach the address. The door is open and swings into a spacious, empty entrance way. Candlelight flickers against the wall. Coats and capes and shoes and bags have been dropped on the tiled floor or thrown over chair arms. I find my way behind the foyer to a large room. People are relaxing on plush carpet, on divans, on chairs. Some linger outdoors on balconies facing dark, leafy trees and inky passageways. A beautiful, dark-haired woman looks at me from a couch.

I live in Paris with Ken, my husband, who is a tall, lean, redheaded man, nine years younger than I. At the moment of this story, he's a painter and a locksmith; he's not changing anyone's locks in Paris though. Ken's hair gently waves, his beard is shaved close, his eyes are a ruddy brown. He has high cheekbones, and a longish nose. Old Russia is written on his face; he's Vronsky, Alyosha, and even Ivan all wrapped up in one. Ken is one of those handsome men who don't know it. He is also a deeply private person whose kindly, smiling face could fool you. He's much more self-absorbed and detached than you'd think. I like the distance, and have many pictures of him from the back, or the side—painting, changing a lock, talking on the telephone.

Ken is wondering how to be a full-time painter, I am eager to walk the city and be alone. We live in the Fifth Arrondissement in two small rooms seven stories above rue Monge.

The search for Victorine is slow. There are days when it's easygoing and full of pleasure, and others when I bog down in paralysis and nausea. The journey always starts with the endless descent to the street. Sometimes that entry is a long sweet slide into an old familiar dream, and it's my father saying, "Ah, Paris, that's where you have to go, Eunie. It's the most beautiful city in the world—the streets and the lights and the river Seine. Everyone spends their days in cafés talking about interesting things and sipping coffee. Or they sit by the river and read Zola. That's a city for you." If the day starts this way, then everywhere I turn will be magic with possibility and the heat of my father's desires. But other days are bleak; a cold, bloodless woman hovers nearby sneering derisively at me. Her message is, "Better stay home today, dearie." I often do.

At the beginning, a good day finds me confidently heading to the Bibliothèque Nationale. The Métro drops me at the Palais-Royal, just a few blocks from rue Richelieu and the library, and that's where I meet my first temptation. Do I take the streets briskly, arriving in five quick minutes at my destination? *Or* do I choose the Palais-Royal garden route? I can't resist the garden—the blood-red roses, the silver statues, the history. Especially the memories of Colette high up behind one of the merry striped awnings. And then, depending on my mood, I can or cannot forgo the calming rhythm of the arcades or the conjuring of eighteenth-century revolutionary uproar—prostitutes, journalists, noblemen, and bourgeoisie thrown into unexpected intimacy. Some-

times I daydream in front of an antiquarian's display. Could Victorine's paintings . . . ? At the end of the garden I look through the windows of the restaurant, Le Grand Véfour, and imagine Ken and me dressed up, him tall and elegant in his white silk suit, me urbane and pensive in my cool black dress. Now we're being greeted by the maître d'. Now we're being seated respectfully among the baroque bric-a-brac and the flower-bedecked mirrored ceiling. Under the table, Ken finds my hand.

The initial research on Meurent is very satisying. I give myself a lot of leeway, permission to dally through material, to linger without knowing why. I'm searching for any clues that will let me sketch a new picture, anything that will distinguish Meurent from the tragicomic cartoon figure drawn by the Art History literature. I find my place in the Cabinet des Estampes, the art room at the Bibliothèque Nationale, take it daily, and read what little exists in the Manet biographies and other artists' memoirs. Near the beginning, however, I have a nightmare that stops me in my tracks.

In the dream I am working happily away in a place that reminds me of Venice, and in a building like the Frick Collection or the Duke Mansion on Fifth Avenue, where I went to graduate school. I am far up above a marble staircase past a balcony in a large room with long tables. I am alone. My table is full of big open art books, but there is no crowding. Then I am called below; there's a message for me. Lightheartedly, full of such

deep contentment, I start to descend. But no sooner am I out on the balcony and heading down the steps than I notice a fair-skinned, dark-haired, very dark-browed woman in a Kelly green suit. The lines of her brows go straight across her face. She stands quietly, to the side of a tall glass case. My body goes cold. But I continue down the staircase. I pass a statue of a very slim man from the eighteenth century—tight clothes, insinuating gestures. I pick up the message below and come, this time very slowly, up the stairs. At the landing I stop where the statue is. He begins to talk to me. I don't want to talk. He insists, and I force myself. He gestures too much with his long arms and fingers. I hate him. Finally I leave, and even more slowly ascend the remaining stairs. At the top, the dark-browed woman steps forward. I try to run . . . scream. But I can't. I fall into a swoon. The statue, just behind me now, grabs my shoulders, the woman, my legs; one of them—I think the woman—touches my vagina, and I die.

Next morning I can't get up. Sunk deep into the pillows, I sleep on and on into the day. Finally, I have some coffee, but I read all day in bed. Ken wonders what's happening. "Oh, nothing," I say. "I need a little inspiration. I'm just going to read today." At dinner I try to convince him that we should go away for a few days. I tell him we need a vacation, a fuel-up before we really get started. He says, "Eun, are you kidding? We've only been here a week."

I see his point. Also, I've had dreams like this before. They began when I started writing seriously in my late

twenties. They come when I am starting a project, and always at the particular moment where there is no turning back.

I return to the library. I call for archival material instead of books. Most important are Manet's papers—his letters, notebooks, accounts, invitations to his memorial, and so on. Maybe I'll find a note he wrote to himself about Meurent, a desire to reach her for some reason. Or a piece of gossip about her that he told someone else in a letter. Maybe a notebook reference to her artistic aspirations. I turn over each letter, each notebook page, savoring the transgression of perusing private words in a public space. But I find no reference to Meurent except the address of a "Louise Meuran" in one of Manet's notebooks. I presume that's her; Victorine's middle name was Louise. No mention of her in letters, nothing among the material from Manet's memorial dinner. She either was not invited, or she decided not to sign the book. Undoubtedly the former; women weren't invited to such events. Indeed, only men left their signatures. Meurent's relationship to Manet was as a model—we know that—and one whom he had depicted only nine times. Yes, it was said that she painted a little, but why expect an invitation?

Here's why. Meurent's name had been known as early as 1862 when Manet painted her as an *espada*. One didn't ordinarily know a model's name. And what a picture of her that is, dressed in male costume, posing for one of the most aggressive masculine activities imaginable, the naked-handed killing of a bull. All the pic-

tures Manet made of Meurent are among his very best
and most famous. One could say that his reputation was
made with her face and body. Manet didn't usually hire
models, though certainly he did occasionally; he painted
his colorful Parisian friends and acquaintances—sing-
ers, poets, writers, politicians, courtesans. Like Leo-
nardo da Vinci, Manet enjoyed a good conversation as
he worked and the inspiration of an engaged life. Why
couldn't Meurent offer such stimulation?

Obviously, I've decided that the personage in Ma-
net's paintings is the Victorine I'm looking for, a willful,
shrewd, street-smart woman. I don't care what all the
writers said, all those picturesque evocations penned by
Zola, Duret, Rivière, Tabarant, *et al.* Why *not* expect her
to go to his memorial dinner? So what if women never
participated?

Manet's best paintings were of me. We had a good rela-
tionship. Certainly, I was sorry when he died, a man not
much more than fifty who had a lot of work left in him.
He was a good painter. I didn't like all his work, but
what's the difference? I knew I would miss running into
him, though. He was always interesting to talk to. And
who can deny it, the scandal over *Olympia* was amusing.

That memorial dinner! They always did things like
that. The great men in somber dress, drinking their good
wine, really toasting themselves and their good luck. I
thought they might invite me, but it was impossible.
Who was I to them? Nobody. A curiosity. Anyway, a few

months later my mother became quite sick, and I had to move out to Asnières to take care of her; I wasn't thinking much about Manet. It was a hard time for me. I didn't want to be in Asnières with my mother either. I was quite preoccupied with work, my lovelife, money—everything.

It was the mid-1880s, there'd been a depression, money was tight. I had a hard time concentrating on my work. So in Asnières, I was preoccupied. I'd get up in the morning, do my magazine illustrations—that's how I earned money—tend my mother, put the drawing aside about noon, planning to paint in the afternoon, and we would have what I expected to be a quick lunch, which never turned out quite that way.

I'd prepare something nice, we'd eat. I'd be getting ready to go back to work, and my mother would start remembering things. She'd talk about bringing me to her shop and going to the zoo together. I didn't remember any of it.

Listen, I didn't do much of my own work in Asnières. The months went by in a haze. I did write to Manet's widow though. It had been on my mind for a long time, especially as money got tighter. And Manet had told me he had put something aside for me. I told her about my difficulties; I even mentioned my mother. I threw something in about a broken finger. I exaggerated here and there. Well, *tant pis*, she never answered anyway.

Next, I take a look at the Adolphe Tabarant holdings. He is still the major source on Manet. Many others have written, some extensively, about the artist since Tabarant's publication of *Manet et ses oeuvres* in 1947, but he remains the place where one starts. I am hoping to uncover his original source material, papers touched by Manet's hand or others who knew him well and who might have known Victorine Meurent. But Tabarant's papers turn out to be surprisingly sparse. I ask one of the librarians where the rest of the material is. He doesn't know, but gives me the phone number of a woman in London whom I call. She says the papers are in New York, at the Pierpont Morgan Library, and don't I know that?

This feels like an omen. Why are these papers in New York? *I* live in New York, Victorine Meurent didn't. And *I* am in Paris, where it is appropriate that I be. Then I remember that six of the nine paintings Manet did of Meurent are in America—two in New York, two in Boston, one near Hartford, one in Washington. Was there a secret admirer in the States who was behind the purchase of at least some of these paintings—perhaps, for example, *Woman with a Parrot* in the Metropolitan, which was bought in 1881? People say that it was after she came back from the States that she started to paint. Maybe there are paintings of hers in New York and not in Paris, after all. I remember a story regarding a man named Étienne Leroy and American collectors. Leroy was involved with the purchase in Paris of the first paintings for the newly incorporated Metropolitan Museum

of Art. Whether Leroy went to the States is not known. Whether he is the same Étienne Leroy whom Victorine Meurent noted as her teacher in 1876 is also an enigma.

What had she done in the States? And how did she get there? Stories are rampant, but all turn on romance: "Oh, you know that Meurent, some rich boyfriend took her off."

Ken says, Call Michael. He'll go over to the Pierpont Morgan and take a look for you. Michael is a private detective and an aspiring writer. I knew, and Ken knew, that he'd be a good person to send to the Morgan; he's a charming, handsome man, and in this instance his dated machismo might work. He wouldn't take "no" for an answer. Obviously I couldn't ask him to comb the material for relevant information; he had no idea what I was looking for—I hardly knew—but I could ask him to try to locate a letter that Meurent wrote to Manet's widow, and that Tabarant quoted at length in his book. As expected, Michael finds the letter and sends me a copy along with some quips about the surveillance he was under while in the library. Librarians are an ilk he is clearly not familiar with.

Here is Meurent's letter:

Asnières, July 31, 1883

Madame,

I beg you to excuse me if in what follows I revive your grief over the extraordinary and greatly mourned Monsieur Manet.

You know without doubt that I posed for a great

many of his paintings, notably for *Olympia*, his masterpiece. M. Manet took a lot of interest in me and often said that if he sold his paintings he would reserve some reward for me. I was so young then and careless. . . . I left for America.

When I returned, M. Manet, having sold a great number of his works to M. Faure, told me that he was going to give me something. I refused, enthusiastically thanking him, adding that when I could no longer pose I would remind him of his promise.

That time has come sooner than I thought; the last time that I saw M. Manet he promised to help me get a job in a theater as an usher, adding that he would give me money to secure it. . . . You know the rest, and what a rapid sickness ravished your loved one.

Certainly I had decided never to bother you and remind you of that promise, but misfortune has befallen me: I can no longer model, I have to all alone take care of my old mother, who is now utterly incapable of work, and on top of all this I had an accident and injured my right hand (a broken finger) and will not be able to do work of any kind for several months.

It is this desperate situation, Madame, which prompts me to remind you of M. Manet's kind promise; M. Leenhoff and M. Gustave Manet can tell you that M. Manet certainly intended to come to my aid. If in my misfortune, and in remembrance

of him, you will be so kind as to interest yourself in my destiny and can do something for me, please accept, Madame, my deepest gratitude.

I am respectfully yours,

Victorine Meurent
7, Boulevard de la Seine
Asnières
Seine

Most of the letter was reprinted in Tabarant, and I had read it, but still the handwriting thrills me. It's neat and constant. Controlled. Also, it's clear that Meurent took herself seriously; she considerd her role in Manet's paintings significant.

Next, I take my search to the Jacques Doucet library, down where boulevard Montparnasse meets avenue de l'Observatoire. It's a clear, balmy day as I round the southern tip of the Luxembourg Gardens heading toward the red fortresslike library. I have every intention of going directly in, but something urges me down the avenue until I reach one of my favorite sights in Paris, a fountain of galloping stallions by Davioud and Carpeaux. Sleek and hungry, the horses pound and twist in the water's foam, as steamy a band as Rosa Bonheur ever imagined, as voluptuous as Courbet's bathers. Sprayed by the mist, and daydreaming, I notice a bulky woman on the other side of the fountain. She reminds me of my mother.

Once when I broke up with a lover, and was in

terrible pain, my friend Marcia said to me, "Let's go to London for Christmas." I didn't want to, but I went. One day I came back to the hotel and found a beautiful, broad-brimmed, rust-colored velvet hat on my pillow. Marcia bought it for me. A few days later she said, "Let's go to Paris and get some perfume." I said, no, I'm not interested in perfume. But we went, and I bought perfume.

Back in New York after the trip to London and Paris, I returned to my shrink appointments; I was in analysis four times a week. On the first day, as I lay down on the couch, savoring being home, I spoke of my beautiful new hat, I mentioned the perfume. Then I lay there quietly for a long time. "My mother had a wonderful smell. Her body. . . . And she'd get dressed up and I'd watch her. And she'd touch my face and kiss me. And just before she left, she'd put on a beautiful hat. My mother had hats with veils and feathers and bows and velvet. And she'd kiss me again."

I leave the stallions and the fountain and walk up the steps to the library. They have nothing for me. Nothing hidden away. No secret papers in Manet's hand with Victorine's name scrawled across it. No memoirs of friends of the painter musing over the strange and headstrong redheaded woman. Nothing.

Someone suggests that I search for traces of Meurent in the archives at the museums—the Louvre, or the Musée d'Art Décoratif, or the new Musée d'Orsay. I don't

like receiving suggestions. You'd think I'd be grateful, but I'm not. I feel pushed. I want to do things my own way, at my own pace. Let people wait till I ask for advice. Paris is just the cocoon I want now. I can languish in cafés, stroll the tree-lined boulevards, sniff the sexual and culinary aromas. I can do anything, go anywhere, and say things I wouldn't in English. No one will notice. I feel like a child playing blocks near someone who loves her but lets her be.

I had this same feeling years ago in Carpentras, a town near Avignon where I was doing research on Eva-riste de Valernes, a friend of Degas. I used to breakfast on the town square so I could gaze out at Mt. Ventoux—so far away yet visible, its face always there, full of sweet promises. A covenant, really. I remember the women, too, going to market. Seven-thirty in the morning and the breeze blowing, they passed before me wearing sensible skirts and shoes, and dark blue mannish sweaters, wartime sweaters, buttoned in front at the bottom, with roomy pockets. Gliding by they showed their fair faces, their committed brows and straight noses. From their arms hung baskets.

I was directed to a villa; its owner was said to possess many paintings by de Valernes. He was old and stooped, kindly but distant, and he went on and on about his many rosemary plants; his house was called "La Romarin" (Rosemary). De Valernes didn't interest him. He asked a servant to display the paintings for me on the floor against the outer wall of the verandah. And

there they sat without frames, naked in the heat of high noon, waiting to be paid attention to.

Where are Victorine's paintings?

No, I don't want anyone's unasked-for help in Paris. I want to go my own way, alone. So, every time I am offered assistance, I get irritated. I say to myself, "Look, there was no life, just an interesting face. Eyes. A big maybe that went nowhere. Forget it. Go home. Go to sleep."

I take the suggestions, though. I'm a scholar and a professor; I have to be responsible. I go to the museums. First to the Musée d'Art Décoratif. Nothing. Then to the Musée d'Orsay. Very comfortable, but the same old books on Manet, and of course, pictures of *Olympia*. Everywhere I go there are reproductions of *Olympia*. Just as I am about to leave, a young librarian suggests looking next door in the artists' dossier department. "Perhaps it will be worth your while, madame." I smile, and push the glass doors into the adjoining department. It's hard to get anyone's attention, and when I do— smiling all the time; one must be charming in Paris— clerks and librarians shake their heads and show me pictures of *Olympia*.

"Oh, yes, a wonderful painting, but would you by any chance have a dossier on Meurent, the model? Yes, she was a painter."

"Vous êtes certaine, madame?"

"Yes." Quite. "Her name was Meurent. Victorine Meurent."

"I'm sure that you won't find anything here, madame."

"Might you perhaps take a look? *S'il vous plaît.*"

Several minutes later, one of the clerks, a young woman, returns, her mouth tightly pursed, and hands me a slim folder with Meurent's name on it.

Atop what appear to be two pieces of normal-sized paper is yet another reproduction of *Olympia*. But . . . just behind the picture is some kind of document. I begin to shake. It seems to be an exhibition form. Yes, that's it. There's a list noting the salons in which Mlle Meurent participated. And then there's something else, something in the top left-hand corner, but I can't bring it into focus. I try to assemble the letters. I'm trembling violently. Then I get it. Above Meurent's name, written in longhand, is *"décédée, 1928."*

Dead in 1928? Writers had her an old woman by 1892, a broken-down, impoverished alcoholic, the suggestion being that she died soon after. I hear myself talking too loud and laughing. I want to hug everyone in the room. In that oh-so-dignified-Parisian archive, I'm hopping from foot to foot.

And there's more. Meurent was known to have exhibited her paintings in 1876, 1879, and 1885, but this dossier indicates that she also showed in 1904. The document further shows that she became a member of a significant artists' organization, the Société des Artistes Français in 1903. And most cryptically of all, that she received emergency aid—*secours*—from the Société in 1909 and an *allocation de guerre* during World War I.

This society had given Meurent thousands of francs. Why? Who was she to them?

Now I have the beginnings of a story to go with this woman's wonderful face, a real woman who lived to an old age, through the end of the century, a world war, and the 1920s, and who, despite the circulation of gossip cum Art History, had continued to live a fruitful life outside of established scenarios, on the very edge of what was possible, a woman who wanted—among other things—to be a painter, and who seems to have succeeded—up to a point.

"Well, thank you very much, *messieurs, mesdames*; you have been very kind. *Au revoir. Merci.*"

Bye-bye.

Victorine is alive!

Paris works its magic on me. I know, I'm predisposed. Most Americans do tumble easily into the luxurious lap of this city. No matter our actual ethnic background or political philosophies, we are all Protestant capitalists longing for permission to play. Headlong we rush to Puccini's love-drenched attics; the grapes, wine, and foie gras of Renoir's picnics; the lazy flow of Monet's rivers. We are not deterred by Zola's moralizing. We ignore the down-at-heel and dissolute as we heartlessly window-shop the boulevards they stumble down. We take the pleasure.

Now, the Paris art world is as clouded in fantasy and myth as everything else about the city, but it's possible to disentangle some social facts from romantic

myths. If we conjure artist-geniuses working, nearly famished in their garrets, struggling against all odds to paint their hearts out, we can also imagine something more ordinary and more accurate. To begin with, the Paris art world in the 1860s and 1870s bore little resemblance to today's. It was a much smaller affair, both more intimate and more attenuated. No avid market pulsed at its center. The Church, the State, some rich nobility and bourgeoisie bought and commissioned work out of the government-funded Salon. Commercial galleries had only just begun to emerge and with them a network of critics and collectors. Until the 1860s, a middle-class person with an appetite for modern painting, and a desire to make purchases, visited backrooms of antique shops, or frame shops or art supply stores. The best known of the latter is Père Tanguy's, commemorated so touchingly in Van Gogh's portraits of the Breton peasant sitting nervously amidst a cache of Japanese prints.

If an artist was ambitious, the only place a reputation could be made was the yearly Salon. It drew enormous crowds, as many as fifty thousand on a free day. Everyone came, rich and poor alike. It was an event, rather like the races or a day at the zoo. And an artist's stature hung on it. In *The Masterpiece*, Zola evokes the misery of the artist Claude Lantier, when he witnesses the crowd's derision in front of his painting. Berthe Morisot, writing to her sister, Edma, about Manet's anxiety at the Salon of 1869, says, "I don't have to tell you that one of the first things I did was to go to Room M. There

I found Manet, with his hat on in bright sunlight, looking dazed. He begged me to go and see his painting, as he did not dare move a step. . . . He was laughing, then had a worried look, assuring everybody that his picture was very bad, and adding in the same breath that it would be a great success."

Manet was irritated with his friends Monet and Degas when they decided to exhibit elsewhere than the official Salon. He insisted that to make an artistic difference one had to first change the minds of the reigning authorities, in this case, the judges of the Salon. But Manet was wrong if one considers that the great successes of the Salons of the 1860s and 1870s were works by Jean Léon Gérôme, Adolphe William Bouguereau, Jules Breton—artists we hardly hear about today.

Nonetheless, until the mid-1880s the Salon was an artist's only chance. In order to be chosen, you had to go to the École des Beaux-Arts, because the Salon judges were professors there. If the professors didn't know you, for all intents and purposes, you were persona non grata. Women were not formally admitted to the École until 1897. In any case, as Linda Nochlin pointed out in her essay "Why Have There Been No Great Women Artists?," artists in general were middle class. The poor didn't have the time to study; they needed to earn money. The rich didn't have to learn anything; they had money. One wouldn't expect to find a working-class woman becoming an artist. A model, yes, but not an artist.

Although opportunities were limited for middle-class women, they did exist. Their parents could hire tutors and, with the right connections, procure the assistance of renowned artists. Berthe Morisot and her sisters were privileged in this way. In addition, starting in the early 1860s a number of Beaux-Arts professors opened studios for women. Among them were Charles Chaplin, Thomas Couture, Rodolphe Julian; and in the 1870s, the Belgian Alfred Stevens had such a studio. In these ateliers young women took criticism from visiting academicians like Gustave Boulanger, Tony Robert-Fleury, and Pierre Cot.

But who can imagine Victorine Meurent in these classes? They were expensive; they were for ladies. Working-class women, it seems, only entered these establishments as models and cleaning women. But can we be so certain that all the women who worked as models were completely satisfied with their work, that they never wondered what it would be like on the other side of the easel? That they never painted? Obviously, Suzanne Valadon and Victorine Meurent had. And is it really so inconceivable that as women lingered at the model market at place Pigalle waiting for work, they talked about art?

So it seemed Meurent lived to a ripe old age. And exhibited a number of times at the Salon and enjoyed some success as a member of a prominent artists' organization. Now it's evident to me that I have to find my way into the civic archives and leave the world of

Art History behind. I make a date with my friend Patrick, a labor historian. He is a burly, friendly fellow, who knows everyone and introduces them to each other. He also knows the archives of Paris inside and out, and this evening over dinner he tells me about the importance of notaries. He says, First locate where the person died, get the death certificate, and then find the notary. They know everything, but most of all they can tell you who the deceased person's inheritors were, and what remaining possessions became theirs. What paintings some old woman left on her walls and in her cupboards.

Next day, I set out across the Seine to the Archives of Paris. After establishing my credentials and getting my outsized but very tastefully colored beige identification card, I begin my search. It is not hard to find Victorine's birth date. It's in one of the slate-green metal cabinets tucked far back in the room:

Born February 18, 1844.
Baptized February 19, 1844.
Église Sainte Elisabeth.

But there's no death date and no marriage date. This is odd. Patrick told me that death dates appear on these forms, that it's the job of certain clerks to go back to the birth certificates and enter the death date. People say, find the birth date and you'll find the rest. Of course, it isn't a reference to the birth certificate that I've found, it's a notation of the baptismal certificate. I know I'd

better go to Saint Elisabeth's. I nod *merci* to no one in particular, and leave.

A trio of young clerks—a woman and two men—are chatting at the bottom of the stairwell outside the entrance door. Just within is a telephone awkwardly situated, as is so often the case in French institutions; it's both squeezed into a narrow corridor and in full public view. I want to call Ken, but I don't want to call attention to myself. God forbid the clerks should think I can't do research without calling my husband.

I call. And there he is, the warm but slightly distant hello, the midwesterner's greeting my Detroit companion gives to the world. He asks, "What's happening?"

What's happening? How can I tell him that one minute I'm looking at the baptismal record, and the next I wish I were in a nice warm bed far away? That I'm standing at the telephone, and I know I look like a professional woman, but I'm not, I've become a shadow of myself, the ghost of Eunice. Someone's after me, like the witchy woman in my palazzo dream. It's Trudy. She's come up out of nowhere to warn me that if I stay longer, it's all over. That I'd better leave now, better go to sleep, drop out of sight, get lost. She always does this to me. She waits for a moment when my guard is down, and she slips in.

I can't tell Ken this; he won't get it; he's too sensible. "Nothing much. How about you?"

Still, I want him to tell me to come home, let it go, like my father used to when, in the middle of the night and unable to study anymore, I'd wake him. He'd get

up, soothe me and say, "Forget about it, *maydeleh*, you're too tired now, don't worry, you'll take the test another time." But not Ken, he'll tell me I've found something, that I should keep at it. Go to the church, see what's there. Thanks a lot, Kenny. You can sit in your studio daydreaming for hours, but I can't come home and hide? Can't you understand that finding Victorine's baptismal certificate is practically finding nothing? It brings no legacy, it discloses no new names or addresses. I wanted to find the simple facts of her life. Is that too much to ask? Patrick said it would be here, so where the hell is it? I know I'm being impatient. I know it's only a few weeks since I've been looking for her. But it feels like forever.

" 'Bye, darling. See you later."

Isn't this what doing research is all about—eking out little pieces of information, making hypotheses, convincing others of your wisdom, etc.? So why so impatient? The answer is that I've never had tolerance for the debris thrown off by half answers: "Yes, no, she had a life, she didn't have a life." That's why I've written nice, circumscribed books about criticism and the images of women. It was I who fixed the boundaries, and wrote the rules; I could have issued a blueprint and handbook had anyone asked. Give me a map, some boots, a manageable mountain to climb or even more circuitous paths traversing faraway fields, steep, red cliffs, silver mountains. If only I know where I am going, I can walk for miles, tranquil in my heart. I have to know where I'm going.

I make my way back up toward the boulevard. It's raining. I find a café, and sit down in a corner, hating the dampness.

"Sandwich jambon, s'il vous plaît."

Bread's lousy; it's the rain. Everyone's flirting, having a good time. Paris. Just like my father said. I think I'll have some dessert.

Did Victorine have a favorite café from which she watched the world go by? Did she sit herself down alone, smoke a cigarette, have a glass of wine? Was she quiet? Did she talk a lot? Did she move around the city? Or was she like Zola's Gervaise, bound by the few blocks of her neighborhod and devastated when she turned accidentally into an unknown street?

What did she do in America? Where did she die? How did she become a member in good standing of that artists' society? What did her paintings look like?

I remember well the day Manet and I decided to work on the *Déjeuner sur l'herbe*. Julie and I were seated on the terrace of the Café Geurbois on the boulevard de Clichy; it was late afternoon in the fall of 1862. I saw Manet walking up toward us from the Place. You couldn't miss his gait—a very attractive, confident man. We'd met at his teacher, Couture's, in 1859.

When he saw us, he came right over and asked to sit down. We made some small talk, and then he turned to me in a very deliberate way and asked if I was still modeling. I said "Sometimes" and changed the subject.

Five minutes later he mentioned this painting he was thinking about. He said:

"There is a figure in it that is you." (He could flatter a girl.) "She is in the middle of the painting paying no attention to the two men with her, and what's more she stares right out at you. It's you."

In passing, he mentions that she's naked, and the men aren't. He knew I wouldn't like that. But I liked him. I told him I'd come by.

During the break on the first day, he told me about the other painting. Also a nude. There was to be a maid in it. We enlisted my friend Laura for the job. At first she was interested, but soon she tired of it. She'd never modeled before; she worked as a milliner's assistant in the Ninth, and that was difficult enough for an immigrant and an African. We French, we have our ways. On the second day, she turned to me when Manet had gone out for a minute, and said, "Listen, Victorine, I don't like this—standing here all day with these flowers, while your friend over there passes the time dabbing away at his painting. I'm not interested, you know. I needed the money, yes, and I admit to being curious, but my God: 'Here they are, dear, the flowers your rich boy-friend sent'; meanwhile it's me and the cat that are the real cunts." I knew she was right, but I enjoyed her company, so I tried to convince her to stay, which she did.

Maybe I'll go to a movie, call it off for the day. I go
to Saint Elisabeth's. It is located on rue du Temple in
a working-class district. It's midweek, about two in the
afternoon when I arrive, and the building is empty ex-
cept for a few elderly men and women. It's a large,
ordinary-looking church except for its short central aisle
off of which swell truncated little apses. The ceilings are
high, the color yellow-amber. Can I picture Victorine
here? Do I imagine that she went to church? I don't think
so. Maybe she was confirmed. That would have been a
holiday for the family. I can't see her brooding about
Catholicism or falling into mystical reveries the way the
young Simone de Beauvoir did in a very different church
far across the city on place St. Sulpice.

Off to the left, just as you enter Saint Elisabeth's,
is a gray, distinctly twentieth-century-looking room. Its
furniture is institutional metal chairs and tables, make-
shift shelves. Some drowsy, aimless-looking people loi-
ter in the corners, and along the edges; a few bossy ones
order the others around and guard the coffee machine.
I make my inquiry about Meurent's baptismal certifi-
cate. The woman I ask disappears into a back room, and
returns with: "Madame, you must write a letter re-
questing the record that you want." Of course, I must.
Have I lost my head?

"Merci. Au revoir."

I write. No response. I go back, and this time I find
my way into nondescript offices below ground where
priests are transcribing notes. I get the attention of a

miserable looking father in a soiled habit sitting alone in his cubbyhole. He looks up reluctantly. I smile self-effacingly and ask my question. (Ah, where is my Yankee straightforwardness? Gone, under French cover. Just keep smiling.) He makes a phone call. "No, madame, we have nothing for a 'Victorine Meurent.' *Je suis désolé, madame.*"

"*Monsieur. S'il vous plaît*, could you look again? It would mean so much to me."

"*Oui, d'accord, madame.*" He pulls himself up out of his seat and shuffles over to an imposing bookshelf; he begins thumbing through huge and ancient-looking tomes. Five minutes later, he shows me what I am looking for: Meurent's baptismal entry.

No death date. I photocopy the certificate and leave. The streets are teeming with people, the honking and yelling hurt my ears. I buy a crêpe on the street. Then some nougat. Better go home.

The first time Manet drew me was in 1861. I'll never forget the day. I was out buying paints up near the Butte on rue Lepic, and decided on the spur of the moment to look in on him. I left rue Folie Méricourt at about ten in the morning, wandering west, then north. There was a lot of construction going on, so I avoided certain streets. I kept off Magenta and Lafayette, making my way on Saint Martin. By ten-thirty I reached Saint Denis; the girls who worked the streets the night before were just getting up.

I know those august men, the historians, think I lived at 17, rue Maître-Albert in 1862. They assumed I did, because it's the address I gave Manet. But I only used that place as a studio. It belonged to Julie, who was a guitarist and traveled. Well, I was only eighteen, and though I wasn't exactly a girl with a trousseau, my parents hoped I would lead a more or less normal life. They wouldn't have approved of my modeling, or my painting, so I didn't use their address when people asked. I didn't frequent the model market at place Pigalle, either, although I knew that crowd. But the market was too raucous for me, maybe too competitive also. Besides, I never saw myself as a professional model.

On Lepic I went into Ottoz's paint and frame shop and asked for some tubes of burnt umber and yellow ocher. I decided to splurge on a cobalt blue and also took a pot of varnish. Afterwards I was meandering down the street, and I paused where it turns right and falls into place Blanche. It's a beautiful view. You can see right down into Montmartre cemetery and out to the northwestern edges of the city. That's when I remembered that Manet had a studio over there on rue Guyot. No doubt about it, I liked Manet. He amused me, but it was more, too. He was an adventure, an excursion. At Couture's he was easy to talk to, not at all a snob, and always had something interesting on his mind. Also he was a good listener, and that was unusual. He seemed curious about me. I decided to stop by.

Stepping into the courtyard at Guyot, I spotted his studio. He was working inside. He looked up with sur-

prise and, smiling, invited me in. He was in the midst of filling in a large canvas, a landscape with a pond and figures. Not that interesting—too big and too vague. And you know, the minute I thought that, he said, "I don't know how to work in the couple on the right." I could see why; they didn't fit at all. I suggested removing them, cutting down the painting and concentrating on the fishermen. This took him aback; he said he'd made the painting *because* of the couple. He changed the subject and offered me some tea and asked what brought me all the way out there.

We started chatting about this and that, art world gossip mostly. I felt ill at ease. I inquired about the couple in the picture, and why he had painted it so differently from the rest. He seemed worried, and before I knew it, he was drawing me. I was flattered, but annoyed, too. It didn't feel right. He hadn't even asked permission. Also, he saw the package from Ottoz's that I was carrying. He knew I was a painter. He had to know. It was at Couture's I'd met him, after all, and everyone at Couture's knew I was a painter. Sometimes I'd be finishing up modeling there, and we'd all have a glass together. Some of the men tried to tease me, but they were curious about what I was doing in Couture's other studio, the one for women; they knew I couldn't be modeling—it wasn't allowed there. I didn't say much about it. It wasn't any of their business, and certainly I wasn't interested in hearing their opinions about my work. Still, Manet heard all this. Yet when I came to

**his studio that day, he said nothing. And why that day
to draw me?**

"Home early."

"Yeah, I'm tired."

"Well, take a nap. I'll wake you up later."

I undress, Ken gives me a kiss. I can see he's distracted. He wants to get rid of me just a little bit, to get back to his painting.

When I open my eyes, it's dark. Out the window, lights twinkle on rue des Écoles and skyscrapers light the faraway sky.

"Eun, you up?"

"Yeah, I am." He nestles into the couch with me, his red hair, his long body smelling of oil paint.

"What've you been doing all day?" I ask.

"You know, I've been thinking about my father. What he'd say if I decided to be a painter, period, no more locksmithing. He'd think I was crazy, impractical."

"You can't tell. I didn't think you were thinking of becoming a painter full-time."

"I am."

"Paris is really doing something to you, isn't it?"

"What do you think?"

"Me? I think it's a great idea. I've thought so for a long time. It's getting the grant that finally did it, isn't it?"

"Yeah. I think I'm going to write to Joel and tell him I want out of the lock business. He's not going to be happy."

"You don't know, darling. He's not just your partner, you know; he's your friend."

"Wanna go to a movie?"

"Are you kidding?" I love going to the movies with Ken. It's almost as nice as being in bed, the spooning part; you know, when you lie stomach-to-back folded cozily into each other.

After the movie we stroll down boulevard St. Germain, drawn by the lights and the people. It's autumn, and the cafés have begun to live inside their glass windows. Still the bustle, the waiters in their blacks and whites, the red and gold-tipped awnings, the promise of something delicious to eat. We stop at Deux Magots and drink their special brew of hot, thick *chocolat* and fresh heavy cream. Ken says, "Look, Eun, *I'll* make Meurent's paintings. We'll let the famous Linda Nochlin discover them, and then you can write about them."

Harriet, a young American historian, introduces me to the Collection Bouglé, one of the two women's archives in Paris; it's located in the Bibliothèque Historique de la Ville de Paris. The other is the Bibliothèque Marguerite Durand in the Fifth Arrondissement. I find an entry for Meurent in the Bouglé papers, but nothing at Marguerite Durand. I'm surprised to find anything at all, even if it's just a picture of *Olympia* again. Which it

is. Harriet, who is working on World War I French war widows, is full of suggestions. She has some thoughts about Meurent's receiving money during the war from the Société des Artistes Français. She wonders whether Victorine had married and had not changed her name professionally—just as Berthe Morisot had not. Perhaps she had children who supported her before the war but obviously couldn't during it, and so she needed money. And so on.

We go out for a coffee. Harriet asks if I know about a woman writer named Gyp, a virulent anti-Semite.

"No, why should I?"

"Well, she seems to have been friends with some very interesting women at the turn of the century."

It is then that it occurs to me that I might end up not liking Victorine. What if, for example, she were an anti-Semite? I brush the thought aside.

"Ever use the Archives Nationales?" she asks politely. I shudder at the thought of yet another unfamiliar archive—new rules and regulations, cards to fill out. I'm sure the blood drains from my face.

"I'll go over with you. Finish your sandwich."

"Now?"

"Why not?"

When we reach the Archives Harriet introduces me to a clerk. We look at some catalogues. But mostly we inquire about notaries. I am given an address, a special archive just for notaries. If I go over immediately, I'll have time to look around. I know I'll have to go alone;

Harriet has her own work to do, after all. I give her a big hug, and go home.

A couple of days later with one more elegant library card in my possession I search the notary files, but find nothing. How can I possibly find the notary who presided over Meurent's worldly goods when I don't know where the hell she died? (Of course, if she was as destitute as sources have it, she would not have had any worldly goods. I was being optimistic.) A decent fellow suggests that I go to an annex that houses more unwieldy birth, death, and marriage data. I thank him and leave that fairly well appointed library only to take a dive into a veritable archival netherworld.

I find a tiny winding street in the Marais that takes me to a shack in the courtyard of a run-down mansion. It's one of those archives that resulted from the destruction of the Commune of 1871. It is here that records were reconstituted, and it is here that I uncover the birth certificate Victorine made out in her own hand in 1873. It lies cheek-by-jowl with her father's, and is one of the few remaining direct statements she made about her life. On the certificate Meurent entered her birth date; her full name: Victorine Louise Meurent; her sex; that she was the daughter of Jean Louis Étienne Meurent and Louise Thérèse Lemesre, who lived at 39, rue Folie-Méricourt in what at the time had been the Sixth Arrondissement. She identified herself at the bottom of the document as Mademoiselle Meurent. For present address she wrote: 191, rue du Faubourg Poissonnière. She left empty the space for "Profession." No death date is noted.

I had just returned from America when I went to the government office to fill out my birth certificate. I was almost thirty years old.

It was not my idea to go to New York; an acquaintance suggested it. He was a portrait painter who sometimes bought and sold older art to make extra money. He had a potential deal on his hands at this particular moment, because he had learned of a wealthy American who wanted to purchase some European paintings for a new museum in New York. By coincidence, my acquaintance knew just the collectors who would be willing to sell. He needed someone, however, to accompany the paintings to America, and that's what he asked me to do. He said I'd be paid a generous fee that would include my fare, and I would be met at the dock on the other side after which I would be free to do what I wanted.

Well, what was I doing in Paris that was so important, anyway? The occasional modeling job for Manet, drawing classes, my illustration work. It's true people had begun to urge me to send work to the Salon, and I had noticed that some of Couture's ladies had, and even gotten notices in the press, but a chance to go to America? I couldn't say no. I was young and confident; I went. I arrived in early winter, and had my first shock when the harbor came into view—gray stone buildings as far as the eye could see; not a hill, a tree, a curve anywhere. I suddenly started coughing; I couldn't catch my breath.

For the first time in the trip, I felt the water heave beneath me.

The transfer of the paintings from the hold to the dock did not go well; five of the crates were bruised at the corners and edges. As I bent forward to examine the extent of the damage, I heard a loud voice behind me and stood up just in time to see an elegantly dressed, heavyset gentleman waving his arms wildly and coming toward me. I couldn't understand most of what he was saying, but I could see that he was extremely angry. He was the man I was to meet. As soon as he saw that no great harm was done, he instantly became more friendly. He laughed heartily and went to put his arm about my shoulders. I moved out of reach, accepted the payment envelope he extended, and bid him good day, having not the slightest idea what I was going to do next.

Luckily for me, a porter who had witnessed the entire scene took me aside and gave me to understand that he knew of a room I could have in his sister's house, which was located on East Third Street. That was my good fortune. I stayed a few weeks, walked around a bit, even found a place to buy a French newspaper and sip a glass with countrymen who'd left France for their own reasons. But I found the city unfriendly and hard to get around.

I did make a friend, though, a nice woman by the name of Lili. *And* I saw a painting at their new museum up on Fifth Avenue and Fifty-third Street that made a lasting impression on me. It was by Greuze, a portrait

of a peasant girl who was full-bosomed with a worried brow and a tender mouth. You could tell that her body was very strong, but that she was shy. It was an odd combination, and I fancied it.

My new friend, Lili, was a little like the peasant girl, a strong, pretty woman with sadness in her blue eyes. She worked as a cook. We went out to the taverns together and had some good times, but she wasn't reason enough to stay, and I went home after a few weeks, a bit ashamed at how little I'd seen. I do remember that when I filled out my birth certificate back in Paris, I felt proud of myself; I'd gone to America and hadn't liked it very much.

Why had Victorine left "profession" blank on her birth certificate? Perhaps she did a variety of jobs and didn't identify with one in particular, not an unusual occurrence in the nineteenth century. Or she hadn't developed an expertise that she would think of as professional. Or she would never, even when she was older than her twenty-nine years, consider that she had a "profession," because the very idea might strike her as bourgeois and irrelevant. Maybe she was just in a hurry.

That night at dinner Ken told me an awful story that his friend Greg had related in a letter. A mutual friend's loft had gone up in flames and with it all of his paintings. Everything was gone. Imagine a life's work vanishing, just like that.

* * *

It's clear to me that if I want to find out more about Meurent's life and locate the paintings, I must discover the location of her death in 1928 and find the death certificate with a list of her surviving relatives. The only route left is to search the public record in all twenty arrondissements. My hunch is that she died in or around Montmartre or some other northern or northeastern part of the city. Certainly on the Right Bank, but away from the center. Then I think that perhaps, since she lived to the age of eighty-four, she might have died in a hospital in any part of the city. That's why I decide to go to each and every one of the twenty Mairies—each quarter's seat of government.

This search is a desperate move on my part, as I can go to the Mairie at Hôtel de Ville and have them survey the records of the city. I'm not sure why I'm not doing that. Maybe I don't trust them. Or maybe walking suits me; map in hand, I can cruise the city. Or maybe it will just take me longer to discover that there's nothing to find.

This is the routine I work out. I enter the Mairie and go to the section called État-Civil. Usually a clerk at some point acknowledges my presence, comes up and asks me what I want. I smile and say: "I have reason to believe that a certain woman of some renown died in this arrondissement in 1928." If it seems appropriate, I show the person postcard reproductions of *Olympia* and the *Déjeuner sur l'herbe*: "Yes, she was the woman Manet painted here. She was also a painter herself." Either I

bore them or, more often than I anticipate, they say, "Oh, I didn't know that," and are genuinely interested. Then, I hand them a three-by-five card with Meurent's name and *"décédée 1928"* written on it. "Could you at the same time, please, also check under marriages? Thank you so much." I wait. I try not to look eager or nervous. I know distress would upset the clerks; the French have a low tolerance for loss of self-control. But each and every time my body temperature shoots up, my gut twists, my heart knocks about in my chest.

The first Mairie I visit is in the Ninth Arrondissement, the section called Opéra. It contains so many of the streets where artists lived, ate, and amused themselves in the late nineteenth century, streets like Nôtre Dame de Lorette, rue des Martyrs, rue Pigalle, boulevard de Clichy, boulevard de Rochechouart, the latter two divided, with the uneven numbers in the Ninth, the even in the Eighteenth. I suppose, finally, the Ninth is classier, more bourgeois than the Eighteenth. Degas, for example, always lived in the Ninth; he couldn't have lived in the Eighteenth. Valadon lived in the Eighteenth. So, I start in the Ninth. The address of the Mairie is 6, rue Drouot.

It's a rainy day when I go. I take the Métro to Richelieu-Drouot, exit, and pick my way down the street. It's lunchtime—animated talking, gesticulating, eating everywhere. Crêpes with confiture; quiches with ham and cheese; brioches and croissants; roasting chestnuts. I try to maneuver unobtrusively with my umbrella, resolutely *not* looking at the food vendors. Finally I ar-

rive at the Mairie and read the instructions. Happily, there are always instructions: *Escalier A* for . . . *Escalier B* for . . . Then a dingy courtyard. The dull lights behind the large windows provide no comfort. I get confused and climb the wrong staircase. A clerk's grimace reroutes me. I arrive at the right place, pull out my three-by-five card, ask my questions, and wait.

Nothing.

I went back to magazine illustrating after America. I also took some drawing classes with Mlle Rousseau and sometimes dropped in on Alfred Stevens's women's studio. That's why people often saw us together; I was never romantically interested in him. He was a prude parading as a dandy. The most exciting thing I did then was find myself an apartment near Montmartre, at 191, rue du Faubourg Poissonnière. It was on the border between the Ninth and the Tenth. I wanted to move to the north of the city for a long time. I liked the openness of Montmartre, and the mix of people, and the bars. It felt easy there. People said Montmartre was stained with blood after the Commune; they called it *enragé*. It appealed to me. I was a little *enragée* myself.

A year later I moved further into Montmartre, to 1, boulevard de Clichy, on the corner of rue des Martyrs. What a location! And what a building! Up and down Martyrs there were bars and restaurants open day and night. It was possible for women to frequent them alone any time and find the company of other interesting

women. My building had a few two-storey studios, although I didn't have one. I had two smallish rooms, but one was big enough for a large painting, and for parties. I loved to dance.

Many interesting people lived in that building, too. Up on the third floor next door to me were two Danish girls. One did the books for a publishing business, the other was a lawyer's assistant. They were great conversationalists and very pretty. Occasionally I'd see them at La Souris, one of a number of bars near Pigalle that I went to, like Le Hanneton and Le Rat-Mort. Another neighbor was Eva Gonzalès, married to Henri Guérard. She studied with Manet, who did a portrait of her painting, or rather sitting dressed up in front of an easel, brushes in hand.

And my other neighbor—everyone knew her—was Sarah Bernhardt. She had one of the double floor studios. It was the time, in the mid-1870s, when she was sculpting seriously. I often saw her and her friend, the painter Louise Abbéma—looking completely like a man and quite shocking—at La Souris. Bernhardt and I were the same age. She was extremely attractive, though not beautiful. She grew up in a brothel.

Sometimes I'd walk over to place Blanche and eat at Coquet's. It was easy and comfortable for women to meet there, too, and was often full of girls looking for a good time with each other—milliners, seamstresses, laundresses, some hopeful dancers and actresses, some streetwalkers, some secretaries and teachers, too.

It was while I was living on boulevard de Clichy

that I sent work to the Salon for the first time. I'm sure that living there helped me—so many busy girls. That was 1876, and I sent a self-portrait, which was accepted.

I try the quarter where I know Meurent was born, where the rue Folie-Méricourt is located. In her lifetime it was called the Sixth Arrondissement, but it's the Eleventh now. The neighborhood has a special meaning for me, first, of course, because she grew up there—those were the streets she walked as a child and adolescent; but I have lived on this street, too. More than once, Ken and I stayed here with his friend Howie, who lives one door down from Victorine's house; Howie is a well-known writer and clown.

The Mairie of the Eleventh is on place Léon Blum. I arrive at about eleven in the morning. It's packed. People are irritated and in a hurry. When my turn comes I condense my spiel and show my three-by-five card. I skip the postcard reproductions. The clerk throws me a contemptuous look, then does the search. I never know how carefully. I shudder to think. She finds nothing. Meurent didn't die where she was born. Is that good or bad? I don't know. Nowadays people don't want to die where they are born, even in France. And Victorine moved around. This is the girl who'd gone to the United States and become a painter. And still I don't know how that happened. Or what it means.

My mother had a laundry shop on the rue Popincourt, just around the corner from Folie-Méricourt. It was her own business, and it did well. The few times I went, I liked it—all the women together, cozy, friendly, lots of laughter. Peaceful, too. My mother didn't like my being there, though. Once, I heard her telling her sister how the girls were often sick, and also that they kept bad company. So before I started school with the nuns when I was seven, my father and uncle took care of me all through the day. My uncle was a sculptor, my father was a *ciseleur*, a finisher of sculpture. The two of them worked together in my uncle's studio. My father was very handsome, short and solidly built. Smart, too, but with a mean temper.

When I was little, I liked being with them. I remember playing and drawing on their studio floor. My uncle loved me and showed off my drawings. With my father, it was different. Sometimes he was proud, other times he made fun of me. He'd yell across at his brother, "She calls this scribbling drawing?" When the two of them went out on errands, they took me along. That's how I got to know all the shops and the workers—we went to silversmiths, wire makers, plaster suppliers. No one bothered about me. Even though I was small, I was always dressed in overalls with my hair under a cap, so no one treated me like a girl; I was just the Meurent kid. I got an earful! Mostly about how hard it was to

make ends meet. Everyone complained about the emperor's projects. Of course, all my father's and uncle's friends were socialists. Prices were inflated, and that was that. Sure, construction was taking place all over the city, they said, but they all felt it was for the rich: the parks, the sewerage, the new streets. My father's friends were certain all the building was going on to insure that the workers never rose again as they had in '48. But in the 1850s it did provide work.

Sometimes we'd visit other people's studios, even painters. One who, in retrospect, was particularly important was Thomas Couture. We started dropping in there when I was about twelve. My father liked him. I think Papa thought painting was better than sculpting, and certainly better than what he did, finishing other people's sculpture. It was less messy, and the painters were a literate bunch. My father loved to tell people his opinions. So we'd often go over to painters' studios. And although I'm sure that as time went by, it became clearer that I was a girl, nobody cared. One day when Couture needed an additional person for a picture, he asked if I could stand in for one of the male figures. I was fifteen; it was 1859.

I remember the first time I put trousers on as an adult was for Manet, his painting of me as an *espada*. I went over to his studio with the usual mixture of feelings, and a hangover; I always drank a lot before I went to see him when I was going to model. I loved the costume that day, though, those tight Spanish pants. The white silk stockings and little jacket weren't bad either.

Then he had gorgeous yellow and purple scarves; Manet always had beautiful things in his studio. He asked me to wrap the purple one around my head, letting the left-over cloth hang down my back. Then he placed the soft black hat sideways on the purple silk, and I pushed the yellow handkerchief into the jacket pocket. It was a difficult pose with both arms extended. He said I didn't have to hold the sword and cloak, but I wanted to.

That's the day he made that comment about my expression. He said, "I can't quite put my finger on it, Victorine, but there's something about the way you look, your face. You never look at the world as if you need anything from it."

Once I had a long black woolen skirt with a high waistline. I wore it on cold days with soft leather boots, a mouton coat, and a large brimmed black felt hat. I loved nothing more than traipsing through the snow on Greenwich Village's narrow streets in these clothes—the whoosh of the skirt, the hat pulled low, my lips and face warm and cold in the winter sunlight. I felt so beautiful on those days, so full of desire. I was thirty and single, and a handsome, older man loved me and brought me silken presents and poetry. We made love in my big bed as the lemon light of winter days passed into reddish nights.

Walking the streets of Paris could be like that, easy and sensual, imagining everything I want and having it. I've walked cities before, alone or with Ken, or in the

old days with my friend Carol. In the 1970s, when she and I were in our late thirties, we spent many an evening strolling Upper Broadway, a joint between our lips. We'd window-shop, gossip, talk Art History. One night she said to me, "Well, who would you have been in Paris in the nineteenth century?" Who, indeed? A smart Jewish woman in nineteenth-century France. Some enlightened man's wife? One of the working-class women we'd written about: a milliner, a laundress, a ballet dancer? We couldn't imagine. And then Meurent came to my mind. I don't know why, really. Maybe it was *her* powers of imagining. Carol, another redhead, liked the idea and gave me her crooked smile. "Yeah."

One day Ken asks me if I am satisfied.

"Yes, I am. I know that I've turned up very little that's concrete, but I do feel satisfied. Why do you ask? You think I'm wasting my time?"

"No. I was just wondering. Frankly, I don't know where you are these days. You get up, you go out, we have supper. Sometimes we go to a movie. You're not saying much."

"I'm sorry, I don't have much to say."

Am I wasting my time while Ken's painting *chefs d'oeuvre*? His peculiar pictures, two and three thirty-by-thirty-inch panels combined into disjointed narratives about art, pleasure, and his own coming of age— a piece of Bernini pope here, a detail of the Tuileries there, portraits of himself, his father, his nephew mixed in. I don't know what he's up to exactly, but I know he's

filling the house with people, and I have vacated it as, day in and day out, I walk the city pursuing a dream, a ghost.

I decide to go to Asnières, where Meurent lived with her mother when she wrote to the widow Manet in 1883. Maybe she never came back to Paris. I speak to a young woman at the Mairie about my project. She sends me upstairs. No trace of Meurent's death. I am directed back to the office where I started, just to check on the address. Someone suggests that if I locate the building, I can check in another archive for its inhabitants over the years. Back in the original place, the young woman behind the desk pays a little more attention to me.

We pull out large books with maps of Asnières dating back to the 1880s; we could go back centuries if we wanted to. While we are examining these, the young clerk mentions that her boss's hobby is Art History and that we should be introduced. At some point this supervisor appears, a mild, gentle, passive sort of man— quite involved with and quite knowledgeable about the Impressionists, especially Manet and his friends. He follows the auctions and reads the auction magazines. His curiosity is aroused by my problem, and he gives me some suggestions to follow up in the library in Asnières. They aren't very useful, but his interest is encouraging. He's a sweet man. We exchange addresses. Many months later, he actually calls me at rue Monge to mention something he's come up with about Alfred Stevens. He tells me that a group of Stevens's paintings have been

deattributed. "You might want to look at them, madame. Wasn't Meurent a lover of his? Mightn't they be her paintings?"

When my mother moved to the *banlieue*, on the outskirts of Paris, I couldn't imagine making such a move myself. I didn't know why she wanted to. Well, maybe she didn't want to; maybe she just had to. The death of my father, her shop failing and all. By the mid-1880s, she'd begun to drink, too. I didn't want to see it. We had our similarities, you know.

I preferred the 1870s to the eighties. My studio was comfortable and well situated at the corner of Clichy and Martyrs. Everything I needed was within reach. Doing anything at all on the Left Bank took special planning. Sundays and Mondays were the best days for me. I never did any illustrating work then. I'd get up late, put up a fresh pot of coffee, run downstairs for some brioches, and . . . think about things. I always fell to looking at my most recent work, and that's how I'd start painting. I'd scrape down the palette, mix some colors—two straight days of painting if I didn't go out galavanting. Which, of course, I often did. I especially couldn't resist Le Rat-Mort, always good conversation there; besides, I could sell drawings to customers. A lot of the girls liked my work and joked about my subjects. "No nudes, *chérie*?" "*Et les garçons?*" "*L'amour?*" Like that. They liked the self-portrait I did, though, the one I sent to the Salon in '76.

I started it on a Sunday. I was passing a mirror near the wash basin and stopped to take a look. I knew I wasn't exactly pretty, but people were drawn to me. I thought to myself, This is a good face; I'm going to paint this face. I began to draw from the mirror. I started with charcoal but moved quickly to painting directly on the canvas. It was the first time I ever did that. Why not, I thought. I'll work for a few hours and then I'll go out for a walk. Maybe I'll find Janine, although she's probably out at the racetrack taking a good look at the hats of rich women so she can copy them next week. She's a milliner. I didn't take a break. No moment was the right one, and I sensed I wouldn't continue if I paused at all. So I finished the portrait. That was a first for me, to stay at a picture from beginning to end. Hold on to the idea, resolve it, see it through.

What a Sunday!

And then I did the strangest thing. I went over to Le Rat-Mort and got drunker than I ever had before.

When I looked at the painting the next day I liked it, though my whole body was still sick with the effort. That's when I thought, "I'm going to send this to the Salon." During the week, I asked my teacher, Étienne Leroy, and he agreed. "Send it," he said. And they took it. This is the painting that many years later turned up at auction at Drouot's and was called *Bust-length Portrait of a Young Woman*. It was signed "Victorine Meurent, student and model of Manet, posed for *Olympia*." I never wrote that. Maybe someone did it for practical reasons. *Not at all a stupid thing to do.*

Why is it none of the writers understood the rage at *Olympia*? It was my face, they hated my face. Manet knew what he was doing, and he loved my face. Just as when he put a monocle in my hand—and not a lorgnette—in *Woman with a Parrot*. He was telling the world "This woman is not yours." My eyes, my smile, it was for the girls, not the boys. He knew that.

I pick my way through Paris, from one Arrondissement to the next, from one bureaucrat's office to another. No one has heard of Victorine Meurent. We're walking the city together now, she and I. In every arrondissement the answer is the same: "I am sorry, madame, there is no record . . ." And he or she waves my index card and hands it back to me, sometimes with a consoling sigh, sometimes indifferently. I am at a loss.

Some say Meurent died so abject a pauper that no papers were kept, no gravesite marked. Those who say this also have her dead, a drunkard, around 1892: She "returned to her guitar playing where she could, and then came the final disgrace. She descended into alcoholism." We see her "collapsed in a chair against a table on which is located a monkey. . . . With [one hand she] presses down on the neck of a wine bottle." But I know that she lived to 1928. And Patrick has told me with great pride, "France is a republic. In a republic every person's life is valued, and every person's life is documented. A record of Meurent's life exists somewhere. You just have to find it."

It's at this moment that Honor is arriving in town. Much as I love her, I'm in no mood to see her, but I am struck by the irony that it is she who is arriving. Honor, a woman of wealth and bearing, a woman of appetite; Honor, a poet and playwright who is also searching for a lost woman and a painter. The difference is that she has all the biographical documents and evidence I am lacking. Her subject is her grandmother, Margarett Sargent, a troubled, wealthy woman—a Boston Brahmin—whose paintings have dropped from public view, but which nonetheless exist. Honor owns many of them. So, each of us has looked for ourself in a woman from the past—a rich woman and a working-class woman, women of unwieldy appetite—and each of us is attempting to establish the significance of these women's lives. Only Honor is ahead, because she has the facts. I try to put this out of my mind, because Ken and Honor and I are going to have a splendid meal tonight at Jamin.

We dress carefully, get a cab, and arrive on time. We are led to our table. Honor is so full-bodied that the moment she sits down on a banquette, you feel you must be at a Roman dinner or even at the baths; she knows how to sprawl. Not that she does it right away, but you know it's going to happen. She's a woman with her own kind of confidence; her father is a bishop.

We decide to have the *dégustation* menu: chicken soup, filets of *rouget*, a turban of pasta and langoustine in a cream sauce, a partridge wrapped in cabbage, a cheese course, and then dessert. For the soup, I expect grandma, French-style. You know, a nice simple begin-

ning, a gentle overture for the dazzling symphonics to come. A precious tiny porcelain cup and saucer are brought to each of us by a boy who's walked out of a painting by Caravaggio. He tells us, oh so gently, to use our very large soup spoon and plunge it down deep into our little cups. And when we do . . . well, first of all the spoon cuts through velvet, and then hits gentle resistance below. Slowly we pull it up through the resistance and find it filled with a light, savory chicken liver mousse. Oh, the satiny texture of that mousse in the custardy broth infused with the juice of white truffles. Honor and I fall back into the pillows of our banquette. Ken slumps ever so slightly in his seat. We can barely look at each other; we'll erupt in uncontrollable giggling.

The boy disappears. We never see him again.

And that's how the meal goes. I can't possibly describe it in its entirety; it would kill me. Truly I would keel over in spasms of exquisite nostalgia. I will only tell you about the last act: The Dessert. Each of us receives a slice of heavenly chocolate cake. We are delighted. Then comes *crème brûlée*, and we think: How quaint, how brilliant, to end this culinary odyssey with a simple, homey, *crème brûlée*. But no sooner are these plates cleared than to our astonishment four waiters, jaunty as cadets on parade, appear with carts and trays and silver urns. The finale is upon us.

In one urn are sorbets of the most intense flavors and colors; in the other, ice creams to drive the palate mad. And then the carts with their array of pastry to

make the heart stand still. Whipped-cream cakes and wild-fruit tarts, almond this-a's, chocolate that-a's, awaiting their puddles of *crème anglaise*.

By this point, Honor possesses the banquette entirely. Ken is trying to calm himself. I have settled into private reverie. Too bad Linda's not here. Those carts! She would have been on the floor for those pastries, and *after* the chocolate cake.

Then there is coffee . . . and chocolates. We eat for four and a half hours.

Can anyone please tell me what the relationship is between the dazzling intelligence, wit, and sensuosity of French cuisine and the compulsive torpor, humorlessness, and opacity of French bureaucracy?

Janine and I often ate at Chez Coquet. It was inexpensive and the food was abundant. Their specialty was *pot-au-feu*. We met Suzanne Valadon there in 1882; we'd often see her at Le Rat-Mort, too. I remember the year because Jean Richepin, who was a regular at Le Rat-Mort, had just published his novel, *La Glu*, to great acclaim, and that's when everybody started calling me "La Glu" and "La Crevette." I didn't mind. I liked Richepin's heroine, if you can call her that. And I knew that if he had Sarah Bernhardt in mind, he was also thinking of me when he created her.

Richepin's "La Glu," despite her thirty or so years, was slim, energetic, and nervous—*voilà*, the "shrimp." He said her look was intense, "like the sea before a

storm." She's a great talker. "One looked and listened to her avidly," he wrote. "Conversation, discussion, whim, prattle . . . her imagination always ready, animating and transfiguring her." La Glu—"all nerves and pepper"; "less woman than hermaphrodite." Yes, he said that, too. La Glu wore trousers when it pleased her, dressing gowns and dresses other times. "What rubs against her sticks to her," people said. She gets what she wants—money, attention, devotion. They stick to her; she holds on to them.

I never had the power she had, nor the money, but I liked it when people called me La Glu. Isn't it interesting how Manet painted me back in the sixties as both an *espada* in those beautiful trousers and a woman at home in her peignoir, but with her telltale man's monocle? Not so different from Richepin. They both liked women like me. Many unusual men did.

Suzanne Valadon. She was wild. She must have been sixteen when we met her at Coquet's. She approached everybody, men and women alike. Very intense, very ambitious, but ice underneath—shrewd and calculating. She hounded me. Kept asking me about Manet and *Olympia*. Twenty years in my past that was! She thought I had connections that would help her. She found out. And everyone knew I was with Janine. Valadon deserved to be in the street. She had nothing to give anyone.

She got attention, though, that girl. And she was cute. She'd often come in late for supper, after the thea-

ters closed. She'd be wrapped in a cheap tartan shawl and underneath she'd be wearing trousers. Quite the character. You can be sure she was furious at my lack of interest. Sometimes I'd see such hatred in her eyes that I'd think to myself, That girl's going to try to hurt me some day.

Honor and I talk about her grandmother's paintings; we look at slides together and enjoy each other's company. She makes some suggestions, and I decide to go back to where Victorine's paintings make their only appearance today—in the Salon catalogues. I've never checked to see what she exhibited in 1904. It turns out to have been a sketch of a cat and a wasp that puzzles me. How did she get such an insignificant work into the exhibition? The Musée d'Orsay dossier of her Salon exhibits also indicates that she became a member of the Société in 1903. After not exhibiting for almost twenty years, she exhibits what appears to be a very minor effort, and as a member. I decide to pay a visit to the Société's office. They are bound to have something, some explanation. Someone in their office, after all, clearly wrote in longhand *"décédée, 1928."*

"No, madame, we have no record of this woman. All those files were destroyed when we moved ten years ago."

I think I am going to choke to death right here. Then I think I will choke the man standing in front of me,

speaking to me. How can they have done that? What kind of stupid fools are they, anyway? I thought the French kept everything!

That's when I begin to suffer from paranoia. I have had my difficulties, after all, with museum curators and eminent professors. Maybe this is my final punishment. Maybe there *is* an Art History mafia, and now they're going to get me good: they are going to give me a heart attack. These are powerful and vindictive men, the Art History professionals. They can resort to Byzantine, even Machiavellian manipulations. I've witnessed barely veiled threats go out into the Art History community, and young, untenured professors fall to their knees in obeisance. I've seen journal editors abandon every rule of professional etiquette and make unprecedented space for the profession's big shots while eschewing the rights of the lesser-known. I know how curators can bar the doors to their collections.

These apprehensions remind me of an experience I had in the late 1970s. The setting was a weekend-long meeting of art historians at the Museum of Modern Art in New York. The subject was a leading Post-Impressionist artist. All the famous men were there: the scholars, the curators, the writers. No women were scheduled to make major contributions.

As the day's events unfolded, professors and connoisseurs held forth in the usual ways. Formalist, Francophile, and relentlessly ahistorical, people dwelled on the roots of Cubism. Speakers insisted that only "immediate" questions relating directly to the "look" of a

work of art were important. Form was taken to have intrinsic meaning completely removed from daily life, and only "vanguard" art was explored. Even questions of iconography were barely touched upon.

At the end of this first day, a few minutes were allotted for discussion, but no discussion took place. There were many things I wanted to say, but couldn't. I was intimidated.

After an awkward silence, we were dismissed. I went home in a rage. I hadn't been so scared in years. It was the wall of men, the homogeneity of authority. Linda was in Europe, and I couldn't get any Marxist or feminist colleagues to go to the symposium. They said it would be a waste of time.

I girded myself for the next day.

When discussion time came around, I got ready. On the dais all the boys were congratulating themselves. The audience was silent, shifting in their seats, looking at their shoes. No one moved to comment. I took a deep breath and walked to the microphone. I maneuvered it so that I could face both the audience and the men. The speakers were sitting back contentedly. Then they roused themselves, surprised that someone was actually going to use the microphone. They smiled indulgently at me—ah, a nice young woman.

"This has been very interesting," I said, "but it's also quite familiar; it's an approach we all know. We've been reared on the celebration of genius, the mysteries of artistic achievement, 'disinterested' scholarly inquiry, the inevitability of stylistic development." I could

have added: that art is made in isolation by men, and that it can only be appreciated and explained by high priests.

I continued: "Why not use this exhibition, this symposium to explore new issues? Art History, after all, is in evident and exciting turmoil at the moment, both feminists and Marxists—" At this point, a speaker, actually the convener of the symposium, interrupted me in mid-sentence. I said to myself: Wait. Hold on. Don't get mad. He finished. I tried to continue. But the same man interrupted me again: How can you say this and say that—this and that—he erupted. He went on and on. I stood there, thinking to myself, Okay just let him wear himself out. Let him scream for a while. Don't get upset. Then, there was a pause. He took a breath and peered over in my direction. He was amazed that I was still standing there. Just as he was about to push off again, I asked if he was finished. I pointed out—earnestly, respectfully—that it was I who had risen from the audience to say something, and that it was he who had done all the talking. (This man had actually behaved similarly at my Ph.D. orals some years earlier.) He muttered something, but even he recognized that it was his voice he'd been hearing for the last ten minutes, and now some of his colleagues on stage were trying to restrain him. "Well. All right. Go ahead," he yielded. I made some modest remarks about the social and political meanings encoded in works of art. I asked why the history of modern art was structured in one way, along

one route, and not others? I pointed to the painful di-
lemma facing increasing numbers of art historians as
they tried to assimilate social data to works of art and
struggled not to lose the work, the "look" of the work.
Only when I turned to walk back to my seat did I see
the stares, the open mouths. Moments after, when the
symposium was over, and I began to leave, women
swarmed around me.

A few weeks later I was fired from my job at Hunter
College. The symposium was not the first place I had
stated unpopular opinions.

These are my thoughts as I stand at the counter at
the Société des Artistes Français. They are holding out
on me. I am convinced they are giving the information
I need to some people, just not to me.

In 1878 I began a large painting, the most ambitious
I'd ever done. I called it the *Bourgeoise de Nuremberg
au XVIe Siècle.* I know some people would call it old-
fashioned, but this is what I had in mind. I was fed up
with seeing all those paintings of sprawling naked
women. When I set to work on the *Bourgeoise,* Gervex
had just painted *Rolla.* The Salon judges had for a
change been smart enough not to accept it, but even so,
everybody was talking about it. It was a large work filled
with a beautiful bed, gorgeous sheets and pillows, and
a magnificent naked woman. There she lay stretched
out for all to see, her hair flowing out across her arm,

one leg hanging off the side of the bed, the other raised. She slept. At a window brooded a darkly handsome, clothed young man.

I wanted to make a painting of a woman in life, but I wanted also to paint a period piece; I loved copying exotic details like old costumes and furniture and ancient architecture. I found it relaxing and absorbing work, and I knew that the public liked to look at such things. I wanted to sell my paintings, after all. There were many period pictures around, and I knew they sold. In the Salon of 1874, for example, Albert Maignan exhibited *Departure of the Normandy Fleet for the Conquest of England*, and although the women made a wretched group as they watched their men depart, it was a picture of real women, and the State bought it and hung it in the Luxembourg. Tony Robert-Fleury also exhbited such subjects, with the same attention to detail and with great success.

My teacher, Leroy, wondered why I wanted to paint women when male figures, costumes, and activities were so much more interesting. Well, I knew that, but I always admired the way in which both Tissot and the Belgian, Leys, painted medieval women, and I wanted to do something like that. I also wanted to put Janine into my pictures. Janine was my *copine*, well-read, frank, and an ardent admirer of the communard Louise Michel. Janine would have her own shop one day. She was an energetic person with taste. I loved her. And she loved that I painted. We found a place together at 21, rue Bréda, a few steps away from La Souris, which was

at 29. Our house was always filled with friends, and almost as smoke-filled as the bar.

Well, my *Bourgeoise* was accepted by the Salon of 1879 and what do you know but Manet, whom I hadn't seen in years, was at the opening with two handsome pictures—big canvases with lots of paint and color. It was a little hard to make things out in them, and the figures looked wooden and awkward to me, but our styles had always been different. We were glad to see each other; it had been a long time.

My painting got a notice in *Dictionnaire Véron: Memorial de l'Art et des Artistes Contemporains, Le Salon 1879*.

I decide to go back to Tabarant, and see if I missed anything. And I had. There is mention of an American man making inquiries about Meurent at the picture dealer Durand-Ruel in the 1930s. He died before Tabarant could get to him, however. I call the Durand-Ruel archive; they have nothing for me. There is also a notation of a painting by Meurent that sold at auction at Drouot's in 1930. Although I have already searched Drouot's books for possible sales of her work and found nothing, I return with this new fact in hand.

"So sorry, madame, information on that sale is missing. We do know, however, that a Monsieur Cailac was the expert—the assessor—of all the work sold that day." Ken suggests that I look in the telephone book for Cailac. This annoys me—I still don't want unasked-for

assistance—but I do it, and there's the name—and the shop—still at 13, rue de Seine. The proprietor now is a woman, a Mlle Paule Cailac.

Weeks later, on yet another rainy afternoon, I visit the address on rue de Seine. I've had a superb lunch with Ken and his parents, who are visiting for ten days, and have parted from them, content to visit the picture shop; Ken has decided to tell his parents today that he's becoming a full-time painter. Admittedly, it's hard to look elegant, self-possessed and authoritative in a downpour, but I try. Propping my umbrella in a corner of the shop, I draw myself up and walk slowly, smiling, toward a woman who appears to be an assistant. I introduce myself:

"*Bonjour*, madame. I am an American critic working on Manet, particularly his relationship to Victorine Meurent, his model."

"Oh, very interesting, madame. What a face, eh?"

I am astonished; these are my feelings precisely but never do I encounter them in a French person. Eagerly I tell her about the sales catalogue I am looking for—noticing at the same time that an older, shrewd-looking woman is overhearing everything. The younger woman stands up, smiles complicitously, and walks over to the other woman. They speak quietly together, and then come toward me.

"Nineteen-thirty. That's a hard year for documents like the one you are seeking. All the thirties, and of course the early forties, too. Very hard." That is Mlle Cailac, the older woman, speaking.

"Madame," she continues, "I tell you what I'll do. We will look for the catalogue. Why don't you come back next Tuesday?"

They do, and I do, and they have found the catalogue. It contains this description of the painting: *Portrait de jeune femme en buste, de face, panneau de 20 × 14½* (Bust-length portrait of a young woman full-face on wood . . .). The painting is signed *Victorine Meurent, élève et modèle de Manet, posa pour l'Olympia* (student and model of Manet, posed for *Olympia*). The name of the man who bought it is Marcel Fouquier, and he lived just down the street at 30, rue Bonaparte, or so he noted for their records. Much later, I learn that he had an artificial leg and limped, but I never find a trace of him. When asked, archivists and art dealers shrug and allude to the war.

Soon after, I find a description of one of Meurent's paintings, the *Bourgeoise de Nuremberg au XVIe Siècle*:

[A] sample of the styles of the past, which holds little possibility of pleasing the ladies of our epoch. This *bourgeoise* wears a white hat, which hides her forehead and more, while a white headband encircles her face, the bottom of which is covered. Her green dress has sleeves with white openings and is cut in a crescent shape at the chest, showing the white clothing underneath.

It doesn't say much, but it's all I have. It tells me what the work looked like, and it did *not* look like Manet

or any avant-garde artist of the time. More like Tissot or Stevens or academic realists like Marie Bashkirtseff or Bastien-Lepage.

This little description is all there is of Victorine's work? I wish I had a cosmic panopticon and could see into every Paris cellar and every attic in the *banlieue*. Maybe I can devise a very special software program that will let me search every antique store and flea market. I'll type in "Meurent," "Manet" "*Olympia*," "model," and on the screen a shimmering list will tumble. But what if everything was burned on a pyre sixty years ago?

How can I return to the library again, after the auction houses and archives, gallery storerooms and conjured attics? But I do, and I come across two articles that provide me with interesting leads, although one is quite discouraging. Paralyzing, really.

In an essay of 1967 by a man named Jacques Goedorp, I find that Meurent actually was a professional model in the early 1860s and in fact worked for Manet's teacher, Couture. It also turns out that Couture had a separate studio just for women students. The other article is one published by Tabarant in 1932 entitled "La fin douloureuse de celle qui fut Olympia" ("The Sad End of She Who Was Olympia"). It sketches the usual story of Meurent, the model who dabbled in painting, who was a lush and promiscuous. But in this one-page article is reproduced in very black tones a disturbing picture, dated 1890, a painting of Meurent by Norbert Goeneutte. It is the work Tabarant evoked in his 1947 opus on

Manet: "[She is] collapsed in a chair against a table. . . ."
Seeing an actual reproduction of it knocks the wind out
of me. A pathetic woman, no better than my mother,
a sack of a woman bundled in *shmatas*, sagging into
the table. One thick hand leans on the spout of a wine
bottle, the other grips the slender arm of a guitar—
tensile reminders of what her body used to be. The an-
gles and edges of Olympia, the will of her eyes and
hands, have metamorphosed into this, this formless
heap of humanity! And opposite her, instead of her las-
civious companion of old—that febrile, black alley cat—
a monkey romps in clown getup. If Olympia taunted the
viewer and muddled his sexual certainties, Goeneutte's
drunken woman retreats into oblivion.

My eyes cloud with rage. Then sorrow. Trudy's eyes
beseech me: Help me, Eunice, please, help me. Mama.
Tears rush from my heart, I press my eyes shut. Did I
do this to my mother? My mother became a heap of
rags, all her words gone, her desire shriveled, because
of *me*?

I track down a relative of Norbert Goeneutte's, a
great-niece by marriage. I want to see the painting. Mme
Goeneutte is more than happy to have me come over
and examine the *chefs d'oeuvre* of—in her words—this
greatly underestimated genius. She has quite a lot of
his paintings and drawings, and she is energetically
trying to sell them and have people write about them.
She apparently thinks I might be useful. She has a
drawing for the painting Tabarant reproduced in his

article. She also puts me in touch with the man who owns the picture. And in her collection there is another image of Meurent, a scene of a woman at her tub observed from behind with her clothing piled high at the right. The central figure is a large, pale, naked woman with red hair atop a very small, elongated head—a dumb head. It is a savage juxtaposition of buttocks and head.

It brought to mind all the Art History stories I read by all those eminent writers—Zola, Duret, Moore, Tabarant:

> I recognized the red hair and the brown eyes, small eyes set closely, reminding me of little glasses of cognac. [Moore]

> She tried to sell her drawings to her companions of the night. . . . But she no longer drew very well. . . . She descended into alcoholism. [Tabarant]

Had it all come down to this?

The hardest thing that ever happened to me was Janine's leaving in '88. We'd been together for fifteen years, and I loved her very much, and I counted on her. I knew she was disappointed in me though, because I hadn't become the success she'd hoped for. And that hurt, and made me angry. I never saw myself as only an artist; I thought I was someone who did many things—painted,

did illustrations, played the guitar, modeled. I admit, I thought of myself as a kind of personage. I was good at Tarot cards, too. But Janine didn't feel that way. She thought Valadon had the right idea: make friends with influential people, get attention whatever the cost, succeed. So, my painting began to get on her nerves. She'd be coy, angry, cajoling, demanding—anything to get me out of the house, away from the easel. I began to hate her. It couldn't work. I got nasty. She got nasty. It was over. Fifteen years. Gone.

I had to move; I'd gotten dependent on Janine's income. It was through the help of Toulouse-Lautrec whom I'd often run into over the years at the bars—the women's bars where he used to draw—that I found a room on the fourth floor of the building where his mother lived on rue Douai. That's where my old friend Julie found me in 1889. I was drunk the day she stopped by. I tried to pull myself together, but I mostly sobbed uncontrollably and continued drinking. We'd known each other so long, Julie and me. She tried to distract me with a sensational summary of General Boulanger's election and subsequent flight and also news of the World's Fair. She described the exotic foods, and inventions like the telephone, and rubbings from temples in Egypt and India. A day later she talked me into going down there. We both brought our guitars and played and sang. We met many people we knew, amused ourselves, and made some money. But the best part of it was running into old acquaintances, and just seeing I could still have a life—without Janine, that is.

Of course, I didn't like everyone I saw. The artist Norbert Goeneutte, for example; I didn't like him. He recognized me—I don't know how—and stopped to chat. Then he came by the rue Douai. He knew I needed money and asked if I wanted to model. I could hardly say no. But he must have seen the hatred in my eyes when I said, "For what?"

He painted me first as the so-called *Woman with a Monkey*, sometimes entitled *Portrait of Victorine Meurent*. It's a dreary little red painting. He also did one of me playing cards. Then came the disgusting one. I don't know how I did it. I knew it was a mockery, in a way, of *Olympia*—Goeneutte triumphing over Manet. And I said okay. What could I do? I needed the money. So I thought, what the hell, why not take off all my clothes again? But I never thought it would be so hard. I had to struggle not to think of Manet in that situation— urbane, intelligent, witty Manet. So many years ago. Another life.

I remember when Goeneutte said, "Could you lean forward a little, Victorine? Bend over a bit, and raise your leg, rest it on the rim of the tub. Yes, like that. Now, turn toward me. My, what a nice silhouette you make, your body against the light like that."

I despise these paintings of Victorine. I want to rip them up, stamp on them, throw them out the window. How could someone do this to her? Humiliate her, erase her?

Two days later I have a terrible run-in with Ken's parents. We all go out for another nice meal, and I ask them something about the day's sight-seeing. Just to be friendly. They reply to Ken as if he had asked the question. They always do this, it's nothing new. They're nice people, mind you, but when it comes to family, they are exclusive and proprietary. They do not let in their children's mates. Friends, yes, but not lovers. Under ordinary circumstances I ignore this behavior. Also, I only see them once a year at most. And they are a loving couple and have been good parents to Ken; every time they hold hands I know it's their marriage that Ken has brought to ours. But this time when they ignore me, a white rage tears through me, and I decide not to see them for the remainder of their stay.

I know I am not behaving properly. I'm losing control. The brutality with which Victorine's life was debased and annihilated is too much for me now. I feel that I'm losing my own life. Walking sticks and umbrellas menace me, wagging fingers harass my sleep. Raucous laughing rips through my brain; dark, deep closets and locked doors wake me up in a cold sweat, shrieking. I know Trudy's going to get me this time, and for good. I'll never find Victorine.

There *were* some good times with Trudy. I do remember going door-to-door with her selling the *Daily Worker* when I was four. She held my hand. And once we went rowing with her younger brother. She wore a red suit, and you could see her beautiful legs, and she kissed me, and she laughed, her red lips and thick dark

hair glorious to behold and to touch. I wanted her so much.

But I can't let her in, I must never let her in. It's always a trick. Because Trudy's a betrayer, that's the first thing you have to know about her. The mommy mask falls away, and back comes the witch. With one good whack, she'll put me out: Let's remember who's boss here, my dear. Never forget who's boss. Stay low. Crouch. Crouch lower, smaller. Maybe she won't see you. Pretend you're a good girl. Don't move. Just keep floating through Paris looking here, looking there, finding nothing. Maybe her eyes will slide past you. Until the next time.

I'm struggling to pull Victorine's life out of the demeaning narratives that were written and the disgusting paintings made of her, but I know it's I who am stuck, I who am trying to pull free of some ancient sludge. I who am caught in a tale of longing and blame, with neither beginning nor end.

I'm afraid to go anyplace alone, now. I'm terrified to bid Ken the slightest farewell. I tremble when I have to go into the Métro by myself. I run back and forth twice, three times to kiss him again and again. Also, I am convinced that I have found a lump in my breast. I'm certain that I'm at death's door. I walk around sure that at any moment my breasts are going to fall off my chest. I go to see a woman doctor, who examines me and with enormous sympathy tells me I'm fine.

I break off the search and start hanging around the

apartment. I write letters, read novels, watch Ken paint. He doesn't mind having me there now. He's making a sad, very lush painting after Watteau's *Gilles*. Ken's Gilles is in three parts, three separate, thirty-inch-square panels arranged horizontally. On the left are the clown's pearly-gray shoes with their ebullient red bows. In the middle is the endless expanse of white tunic with arms hanging dumbly down and sleeves pushed up into waves of satin creases. And then there's the head—the sad, wistful head of Gilles. Ken doesn't talk about the painting at all. His absorption is complete. I've never seen such concentrated intensity in him. I'm envious, but I think I know what's happening.

Ken's friend, Howie, injured him deeply over lunch a week ago. Ken asked Howie why he had been so out of touch since we arrived. He said he had no friends in Paris except Howie. The two had grown up together in Detroit, went to the same schools, even college, and when they moved to New York, they lived in the same building. Howie told Ken that he no longer liked him, that Ken had become self-centered, humorless and stingy, and that their friendship could never be the same. Howie didn't want to see him.

When Ken came home, he walked into my room, his face filled with tears. He stood there looking at me sadly, a little like Gilles, actually. Without knowing the details, I wanted to kill Howie. Ken told me the whole story, and asked if I thought he had changed and become the self-centered, boring, and mean person Howie described.

How could Ken even contemplate such thoughts, and out of the mouth of that narcissist Howie?

"Fuck him, Ken. Forget it! He's the creep, not you."

Then, before I know it, Ken is making this painting of Gilles, the beautiful white clown, Gilles cut neatly into three even pieces. Going about what seems like his normal business, Ken is punctiliously dismembering his old friend—Howie, the writer *and* the clown. No muss, no fuss, just good old displacement. Pure Ken. What follows is too much for me to take, however. Not satisfied with dismemberment, he decides to follow up the Gilles painting with a triptych of Gilles's head, just the head three times, again horizontally arranged. For weeks we sit down to breakfast and dinner with these chopped heads on top of us. Day in and day out, and Ken chats in his usual cheerful way as if the room hasn't turned into a charnel house.

I walk the city aimlessly now, depressed. Linda is due to arrive any minute. I don't want to see her. I'm dreading her arrival. I am sure she's coming with the exclusive idea of invading my privacy and keeping me from working. Worse, she wants to annihilate me, just like Ken's parents. I don't tell anyone this. I start reading Freud's case study of Ida Bauer, whom he called Dora. The case, first published in 1905, mesmerizes me.

Dora's father brought her to see Freud when she was sixteen and "suffering from what seemed like a hys-

terical cough and from hoarseness." Freud suggested psychological treatment, but his advice was not taken. When Dora was eighteen and again ill with hysterical symptoms, her father brought her back to Freud. She was having coughing fits, a loss of ability to speak, and fainting spells; a suicide note tucked away in a desk had also been found. She was behaving in an antisocial manner in general, but in particular refusing to participate in social events with her father and the K.'s, old friends of the family. Dora's father said to Freud, "Please try and bring her to reason." And the treatment started.

Freud soon discovered that at the age of fourteen Dora had been passionately and unexpectedly embraced by Herr K.—the married friend of the family mentioned above; this had taken place in the older man's business office, where he had invited Dora to visit. As she told Freud, Dora responded with disgust and rushed out of the office. She said nothing to her parents, and she and Herr K. indeed acted as if nothing had happened. Two years later Herr K. again tried to seduce her as they took a stroll around a lake. Dora slapped his face, and ran home; two weeks later she told her parents. This is when her hysterical symptoms began anew. Dora's father confronted Herr K. with Dora's accusation, and K. denied it, saying she had made it up. This was confirmed by Frau K., who contributed the information that Dora was reading quite a bit about sex and telling her all about it. Dora was then sixteen years old. At the time, her father was having an affair, and had been for years, with

Frau K., the very Frau K. we have just heard reporting on Dora's sexual curiosity.

Freud was convinced that Dora loved Herr K., but I find nothing in Freud's text that confirms this assumption. It strikes me as a presumption, and I am irritated by how insistently Freud makes this interpretation to Dora, despite her protestations to the contrary. I am also bothered by Freud's indifference, alternating with contempt, toward Dora's mother and Dora's pursuit of an education.

Freud deduces sexual frigidity and hysteria from Dora's responses to a situation that women today might consider sexual coercion—the stolen kiss in Herr K.'s deserted office, in Victorian Vienna, when Dora was fourteen years old. When Dora tries to protect herself by turning to her parents, Freud says: "A normal girl . . . will deal with a situation of this kind by herself." In a footnote, Freud asserts that what Dora really wants is to be a mother. In the same footnote he alludes to Dora's homosexual love for Frau K.

Two things infuriate me about this case. One is Freud's dismissal of matters that were probably important to Dora; and the other is his unquestioned assumptions about what a woman is and what she wants, as if there were such a thing as "a woman." Never examining his countertransference, Freud made up his own narrative in which he could manage the things about Ida that were distasteful to him. For the historic record, Ida Bauer only lives in Freud's picture of her.

What we have is Sigmund, not Ida, a Victorian male doctor, not a middle-class Victorian woman. The same thing, of course, happened to Victorine Meurent. There is no Meurent; there are only the projections and fantasies of middle-class men who wrote into history the creative and charming avant-garde artist, Edouard Manet, and his pathetic, promiscuous, alcoholic model, Victorine Meurent.

Even assuming these distortions, by what right do I persist in thinking that Meurent was Manet's picture of her, and not Goeneutte's and the image produced by all the men who wrote about her? For if I have archival data that undermines the writers' and Goeneutte's interpretations, the material doesn't entirely support Manet's view either. Far from it. *I know.* I'm searching for a hero, and I haven't found one, and I'm beginning to hate Meurent for her failure. But I know, too, that Meurent both fascinated and repelled Manet's chroniclers. They were afraid of her. Her unmanageability—the steadiness of her gaze, her traveling, her painting, her lesbianism—made these writers pack her all the more diligently into the picturesque category of model.

As I read Freud's *Dora*, I see, really for the first time, how my life is bound up with Meurent's and Dora's, how I have emotionally and professionally contracted to fulfill the desires of others. First my father, then my professors, then lovers. And so on. Where are the women? I am barren of women. Of a woman.

I had a fantasy every night from the ages of seven

to ten. I slept in the same room as my baby brother. My bed was narrow with a metal headboard. First, I turned on my side and faced the wall, then I recited the worries I had for the following day: to remember to bring my reader to school, to remember to talk to Miss Buckley about my story, to get Annie's help with the arithmetic problems before Miss Feder got to me. Then I gave myself this fantasy. I, aged eight, was on a ranch with a bunch of nice guys. Sky King was their leader. He was a pleasant and efficient man, and he liked me and knew I was very helpful with the chores on the ranch; I did everything I was told, and did it well. I fixed things, I caught wild steer, I tied knots, I rode cattle, and so on. I had a wonderful time and felt very appreciated.

This is how the fantasy ended: We were all engaged with one another and having a good time; I was just one of the boys. Then Queen Trudy rode in. She was young and beautiful, commanding and able. Everybody admired her. She dismounted. She took me by the arm to a place where no one could see me, and she smacked me.

This fantasy brought me an easeful sleep for years.

I saw Ida Bauer at the Chat Noir one night. She wasn't really my type, but her being German was intriguing. I tried to entice her to Le Hanneton or La Souris. I should have known better; she was with the Natanson crowd, Lautrec's fancy friends. She was not even polite to me.

In one sense, my life was easier than Ida's; choosing women as my companions was not hard for me. Even as a young woman, my parents seemed less worried about me after they realized I was not interested in boys. I had so much more freedom as an adolescent than other girls I knew. My mother always said that the worst thing that could happen to a girl was to get pregnant and not be married, to be *"une fille mère."* That's really what she had against many of the girls in her shop. Well, they obviously didn't have to worry about that with me.

Listen, I amused myself; I knew unusual people. I wasn't Manet or Berthe Morisot, but I couldn't have been him and had no interest in being her. No thank you! I got a look at her more than once, particularly in the early seventies. What a good girl. Frankly I don't know how she ever managed to paint. And I take my hat off to her that she did. But she was not my cup of tea. I saw her arrive one day at Manet's studio with her mother—always with her mother—very beautiful, and sad, Berthe was, but so correct, always so correct. I'd see her at the Salons, too. She'd try to look at the paintings but was constantly distracted, drawn reluctantly, I thought, into conversations with Puvis, Degas, Manet, Fantin-Latour. Always polite, always nervous, always charming. Not that I wouldn't have wanted to be in on some of those conversations. More than once I saw them all looking at me; I just turned on my heel and walked off in the other direction. Who needed them?

But what really upsets me is knowing what Manet's friends wrote about me. I had the impression that they were taking me in, seeing me . . . a little. But they saw nothing. They had only contempt for me.

Coming home to Ken these days is especially sweet. Maybe it's because our trip is almost over. In the evenings we eat and walk, often up to the Seine. We always pause just where we can see the majestic spread of Notre Dame. One night we notice the march of larger-than-life-size sculpted figures climbing skywards, right up to the top of the cathedral. It's winter. We lean into each other, and then we go home to our little apartment and the fireplace. Ken so handsome in the firelight and the quiet. His long, smooth body, white but flecked with brown, and orange hair down there where you'd least expect it. So tempting, so satisfying.

A month passes, and one morning I ask Ken what he thinks Victorine had been up to between 1885 and 1904. Did he think she kept painting? Did she exhibit? And then what happened to her between 1904 and 1928? Also, what about the trip to America, and the American man who contacted Durand-Ruel? And what about those Tabarant archives in New York? He shrugs. He's putting the finishing touches on a triptych. His father is in the left-hand panel, a gazebo in the Luxembourg Gardens is in the middle, Ken is on the right looking away.

Before we go home I do one last bit of looking. I use the Minitel to see if I can locate other Meurents. The Minitel is a computer attached to a telephone from which you can search addresses and telephone numbers all over France. You can also use it to shop and look for romantic companionship. Everyone said Meurent was an odd name, ending in "ent" and not "ant" or "end" as it did; people suggested that it was Belgian. I don't turn up many Meurents nationally, but there are a bunch of them in Fourmies, a town near the Belgian border. I write to all of them to see if they are related and might not know something about this woman. Maybe they have her paintings. As I wait for responses I begin to think about a strike that took place in Fourmies in 1920, and I fall to fantasizing again about a marvelous, heroic Victorine rising like a phoenix from the ashes—at the age of seventy-eight—to lead a strike! Of course, nothing of the kind turns up. Nothing turns up at all.

In the meantime a graphologist sends me an analysis of Victorine's letter to the widow Manet. I don't put much store in such things, but a few comments strike me. The analyst writes,

It was hard for the writer to recognize her errors or be self-critical. One senses a certain originality of thought, an imaginative inclination, a desire to innovate and a certain power and desire to persuade. It's the writing of someone given to reflection who equally has a tendency to obsess. The writer appears

to be willful and self-contained. In spite of superficial friendliness, she seems to have been introverted. She tended to bring things back to herself; she was egotistical. She appears secretive and concerned with keeping her distance. She had a good sense of money and knew how to turn a profit.

I had fifteen hard years between 1885 and 1900, some bitter disappointments. But, even then, I was lucky. I could still talk myself into almost anything if I put my mind to it. I could be charming, and nothing much scared me. This became even more true as I got older.

Mme Manet never gave me money, but others did, especially Lautrec in the nineties and Tony Robert-Fleury. They both knew how bad things were after Janine left. I hate to admit how long that lasted, too long— a couple of years. Slowly, though, I pulled myself together, and picked up my old trade of portrait painting. My teacher, Leroy, had helped me get into it. Originally, he sent work my way that he didn't have time for. It was the well-off shopkeepers of Montmartre who wanted portraits. Soon, I had my own clientele and recommendations. I didn't love it. But I started doing it again in the early nineties. I also sold work at Le Rat-Mort, Chez Coquet, and later at the Élysées-Montmartre. When things were particularly slow, I dredged up my past and told prospective buyers about my role in *Olympia*. It helped sales. Then, when there was all

the publicity over *Olympia* in 1884 because of the post-humous Manet sale and the auction at Drouot, I even sold photographs of the painting on which I affixed the following: "Victorine-Louise Meurent, exhibiting artist at the Palais de l'Industrie." In 1890 there was an increase of interest again, and income for me, when the work was hung at the Musée du Luxembourg.

Living at 69, rue Douai, saved me, though. I'd see Toulouse-Lautrec there and, coincidentally, Robert-Fleury lived in the building; I had studied with him in the mid-seventies at the Académie Julian. Lautrec came by often to see his mother. Everyone knew me. I was always very social when I wasn't drinking; I could stand in the courtyard and talk for hours. Everyone knew I was a painter. They also knew I had modeled for Manet's *Olympia*. I couldn't escape it.

Finally, it was Robert-Fleury and Lautrec who gave me the money to put down as security for my position as usher in a theater. That was 1897.

Before leaving for New York, we spend three fateful days near Autun.

I mention to some new French friends how much I love Romanesque churches, and they say, Why don't you come visit us for Christmas before you leave and we'll go to Autun for Midnight Mass? Their names are Sommard. She, Aimée, is in her early sixties, he in his early seventies. They're handsome, very intelligent people. He, always called by his last name, has a full head of

silver hair and a mustache still flecked with black. His face is swarthy and lined. A hand-rolled cigarette dangles from his mouth. He wears wools and tweeds. His eyes remind me of my own—steady, direct, unsmiling. Until they smile. Aimée is slim and elegant. Also a touch severe and judgmental.

Their home is magnificent, perhaps especially now in the wintry grays of late December. It's a meandering stone building dating from the seventeenth century. There's a fireplace in the living room that's large enough for two people to walk into. In corners and along the walls, in the center of the room and on tables are magnificent Egyptian, Greek, and French medieval sculptures. Ken and I have never seen art exhibited in such an inviting and unintimidating way. It is simply there for your pleasure. As is everything in the house. We are entirely seduced. We even love the way Aimée hands us a simple porcelain pan when she shows us our room, and points to the balcony from which we can dispose of the contents when we need to.

Aimée was a gallery owner, Sommard a curator and museum director. He's brilliant *and* autocratic, charming and demanding. She, I'm afraid, is his foil. We find that when we awake at nine-thirty or ten, Sommard has been up since five, talking, writing, reading. He lives on words and is ready to go the minute he sets eyes on us. We, on the other hand, before our coffee, can barely communicate with each other in English, let alone with someone else in French. No matter. We sit down to our

morning bowl of coffee relishing everything we can see, touch, taste, or smell. We're at a long, rough, wooden table with huge black stoves in front of us promising hearty fare all day long. The ceiling is low and white and reminds us we're in a French farmhouse. This morning, the view down the length of the room and out the windows is a Monet-blue sky and buoyant Pissarro trees disputing the wind. We'd love to bask in this pleasure for just a few, tiny minutes. *Mais non.* Sommard tosses down before us an article by Peter Handke translated into French—thank God, it's not in German—and demands our opinion. He's continuing a discussion we had last night that I, unfortunately, have forgotten.

It is that kind of stimulation all day long.

One evening amid the comfort of the hearth and the majesty of a carved wooden Chinese horse, I fall to bemoaning my academic life and particularly how hard it is to be both a professor and politically engaged. I don't mention the feminist content of my politics. Also I despise the politics of academia, and although I have tenure and am one of the more powerful women at my university, I continue to encounter an unmovable wall of men at every turn. Whatever the differences among them, whenever they encounter my opinions, they act as one.

Sommard says, "Why don't you quit?" Aimée nods agreement, gaily presenting me with options. I demur, thinking all the while, It's all very well and good for

these people to make such suggestions; they're loaded. Look at this house! And on the drive to the cathedral last night Aimée's mother whispered to me in the back of the car that the vineyards we were passing were Sommard's.

I change the subject.

In America

I am a wreck when we get back to New York—nervous, weepy, angry. I keep falling asleep. Almost immediately, however, I make an appointment to see my old friend Marcia. We've known each other for twenty-five years. It's not an easy friendship, but it keeps going. More or less.

I arrive at our rendezvous early. It's a Soho bar that we like—rather more Little Italy than Soho, and a bit old-fashioned. When Marcia arrives and walks up to my table, I'm standing there with tears rolling down my cheeks. My friends know I'm a cryer, but this seems a bit much. I've only been away six months, and we have corresponded. And all that time I *was* in my beloved Paris.

We hug. She sits down. "What's all the crying about? You missed me that much?"

"Yeah, sure. You know, I don't know."

"You, Ms. Psychoanalysis?"

"Well, it is a shock being back. Something is wrong, Marcia. Marsh, did you ever think of dying your hair red? No? I don't know what it is. Maybe I'm just spoiled. Six months of Paris, and now this, plus having to commute to Binghamton to teach."

"But you were working in Paris; it wasn't just fun."

"I know." I tell her about my search, the days spent walking, reading, meeting Ken, walking some more, eating. She knows; she loves Paris, too.

"Something about my mother, some pushing through, something new. I don't know. Victorine became a companion in a way. Not that I found anything great: a new death date and some awful paintings of her. Nothing *by* her. I read Freud's *Dora*, by the way. Extraordinary. Outrageous, really. You should read it. I don't know, Marsh, I don't know what's going on. I don't want to go back to Binghamton. I know no one wants to go back to teaching after a sabbatical, but I really don't. I—"

"You know what I think, Eun," she interrupts.

"What?"

"I think you should quit your job. I don't think you want to teach anymore."

"You what?"

"I think you should quit your job."

I know she's right. The minute she says it, I know

she's right. All that wandering in Paris, so overloaded with feelings I couldn't manage and yet a desire to keep walking. I had been teaching for twenty-three years. I started when I was just twenty-four. In those days, 1965, you could get a good job with a master's degree, which is what I did. I know I was a good teacher. Everyone said so, had always said so. And I got some satisfaction from it. The admiration was certainly pleasant. Preparing all those courses over the years, I'd learned a lot, too. And I know I changed some people's lives, more than I realize probably. But I'd never really counted the teaching. Writing had always been the place where I measured myself, where I failed or succeeded.

I wanted to quit my job. I went home to talk to Ken.

"You what?"

"I want to quit my job, Ken." He shakes his head.

I tell him about the conversation with Marcia, and he looks at me.

"Listen," he says, "I'm only ninety percent for this."

"Okay. Well, think about it; let me know." Five days later he comes up with the other ten percent. I should add here that just before we returned from Paris, Ken sold his part of the lock business to Joel, his partner, who paid us a whopping five thousand dollars for Ken's half of the business—located in the trunk of an old Chevy and the Manhattan Yellow Pages. We are completely dependent on my professor's salary, health insurance, and pension. It is no small thing that Ken finds the other ten percent. We both know that the burden for the time being is going to be on him and his paintings. He smiles

and says, "Do it." The nut, my crazy optimist. And I
think, this is why I married him; he always tells me to
do it. Go ahead, dream, he tells me. Me! Ms. Pessimist,
Ms. Practical, Ms. Checkbook-balancer.

I write my letter of resignation.

I have to complete my contract and teach for a se-
mester, which means commuting to upstate New York
every week. Frankly, it doesn't make me miserable to
push Victorine to the side as I pick up my teaching re-
sponsibilities. I decide to keep a journal when I am in
Binghamton. I want to undertand better why I quit.
People are already asking me how I did it. They say it
must have been such a hard decision. But it wasn't. I
did it in a second. How *did* I make the decision? Each
day I write in the quiet of the upstate New York morn-
ings.

January 20:

I'm longing for Paris, the search for Victorine, one
day slipping into the next.

Dad's family always tried to fail, or so it seems to
me: him selling his furniture business when he was fifty-
nine and just beginning to make money; Phil his doctor-
brother—the only educated one—satisfied with work in
a VA hospital; Dad giving up chess when he began to
beat the pros. And he never wrote. He said he wanted
to, but he never did it. Not even when I told him about
computers and how easy it could be. But what about
the other brother, the young communist? I heard so
much about the beautiful blond David, dead on a hill

in Spain in 1936. He didn't try to fail. But he died, didn't he? Louis cherishes his memory, hoards his every memento in a shoebox that used to live in back of the closet, behind his ties. Sometimes he took the box down and wept. No one can live up to it.

Is quitting my job giving up?

February 24:

Jan asked me to think about doing a piece for *ArtForum* on Victorine, something like "Thirteen Ways of Looking at Victorine Meurent." What an interesting idea. She's so smart, that Jan.

March 2:

What happened in Paris that made me want to leave Binghamton, leave being a professor? Paris such a place of permission, far from my mother. I want to be there, quiet, left alone.

March 7:

I cried my heart out last night after seeing the movie *High Tide*. It was about a wanderer woman who accidentally finds the daughter she lost many years before.

March 30:

How much is the quitting failing?

I'm depressed. I don't know why. I don't want to work, and I should. I need to hold on to my writing on Boucher, a nice essay about seeing, pleasure, and the

company of women; all those voluptuous women's bodies languishing in rococo softness.

I feel scared, alone. I keep remembering rooms in Hurleyville, with Grandma and Grandpa, upstairs in the winter but before the heat is turned on, wandering, alone. Does writing mean being alone? I want to hide, sleep, get away from the clawing. Mother.

I'll read a little.

Did I read in Hurleyville instead of doing something else? What would "something else" have been? Talking? Nobody really talked there. My father was the guy with the words; words were Louis.

So my father was important? And the "word" Kristeva talks about, the word that is always the Father's? And spitting at my mother, when I was a kid, hating her so much. Was it my fault? Did I kill my mother?

Was my mother's walking away from me in Hurleyville her own desperate lunge at desire?

April 18:

Had that lousy dream about packing up for the concentration camp and the clock going dead. Maybe I don't have to go to the concentration camp this time.

Don't you think I needed my mother? Affection, love, attention? Doesn't everybody need that? Well, I didn't get it. She was too busy. Not that she had other kids. No, I was the only one. She was just busy. At the laundry shop, with her friends, sometimes with my father. I

don't know. She was busy. I felt she hated me; she was so abrupt and distant. And everybody thought she was warm, *chaleureuse, tu sais?* That's amusing! She was a bitch. And she beat me. As I got older, she got subtler, though: I'd try to say something about a book I was reading, and she'd brush it aside as stupid and irrelevant, or she changed the subject. But I got her, I learned how to get her. I started ignoring her, talking only to my father and uncle. And I made friends with older women and flaunted our intimacy in front of her. She grew fatter, smoked more cigarettes, disappeared into other people's rooms. Sometimes she'd turn and look hard at me and try to hug me, as if she'd forgotten something and had unexpectedly found it. I couldn't stand her touching me.

And then, you know, life goes on. You notice your mother, you don't notice her. It's thirty years later, and she's thanking you for things, and asking about your paintings, and even your love life, and you wonder what's happened. You still lash out at her, tasting the blood and the hatred, knowing she deserves it. But you also begin to remember that you loved her once, a long, long time ago, before the hatred. You remember her smell, even her body. You begin to want to touch her. And you're fifty years old.

I never introduced my mother to Janine. They both had big mouths and their own opinions. And Janine was possessive. I thought my mother would get on her nerves. She was loud and unsophisticated, talked fast, left her sentences hanging. So I didn't invite her. I'd go

out to see her alone; usually we'd meet at a café. I didn't
like the trip to Asnières. I didn't care that she wanted
me to visit, that she was proud of the little home she'd
made for herself.

She never saw my studio. As she got older she'd ask
about my work, but I rarely took her seriously. I'd ig-
nore her questions and make small talk. I knew she
didn't care; it annoyed me that she kept asking.

Toward the end of her life things changed. It was
because of Marie. Marie wanted to meet her, so we took
the train to Asnières one Sunday afternoon. My mother
was quite weak already, but she prepared a little lunch
of leek and potato soup, mutton chops, and a nice piece
of Cantal. She just sat there quietly most of the time.
Every once in a while she'd rouse herself and ask about
my paintings, also about the theater, what were the hits,
who were the interesting actresses. Marie and I were
working as ushers then.

When we left and were walking back to the railroad
arm in arm, Marie said, "How come you never told me
how much your mother loves you?"

As soon as school is over, Victorine comes back.
Such a discreet girl. She was just waiting and watching,
the way Manet had painted her in *Woman with a Par-
rot*—one hand holding the violets, the other the mono-
cle, absently savoring the purple petals, toying with the
eyepiece—a little edgy, but patient.

In mid-May I take myself to the Pierpont Morgan

Library to look at Tabarant's papers. This library, on Madison Avenue at Thirty-sixth Street, resembles the Frick Collection. It's a low, stone rectangle, vaguely tomblike. You enter through a tiny vestibule over which presides a man in uniform. It's his job to know where you're going. The second entrance hall is bigger with more marble, a grim but opulent place. Off to the right is a huge, heavy wooden door; it's the door to the library.

Around eleven one morning I introduce myself to the librarian in charge and say I want to look at the Tabarant papers, that in particular I'm looking for information on Victorine Meurent; I write out her name. I practically have to recite my curriculum vitae to get her to give me a visitor's card. Then she says, "There's nothing in that archive that would interest you."

"Well, perhaps I might look at it anyway."

"Very well, I'll show you the inventory if you like and those few insignificant papers which relate to your subject."

"Thank you."

"Come back at one."

One P.M. The inventory. It lists four cartons with specific headings and particular dossiers noted under each. Carton one, dossier eleven, contains a précis of the article "Celle qui fut l'*Olympia* de Manet"—"She Who Was Manet's *Olympia*." Well, that's odd, I think. The essay of 1932 with a similar title is too short to write a précis about. I ask to see this summary. The librarian hesitates. Finally, I am handed eight typewritten pages that summarize an article I know to be no more than

five hundred words. I begin to read it. It's not a summary of the piece I know. There are things here that are not in the other one—amazing things! Comments by Mme Manet's son, Léon Koella Leenhoff, about Meurent; lengthy descriptions of Meurent selling her drawings in cafés; the painter Suzanne Valadon's comments on her. More.

My stomach hurts. "Could I see carton one, dossier eleven, please."

"Very well. But you will have to come back tomorrow. We couldn't possibly get it for you today." It is three o'clock, and the library is empty except for me. Something is going on.

"All right. I'll be back in the morning."

The morning. Dossier eleven. The cover page of the dossier reads: "Victorine Meurent. Typewritten manuscript of 'Celle qui fut l'*Olympia* de Manet' (Victorine Meurent) —'She Who Was Manet's *Olympia*'—by Mr. A. TABARANT 85 p. Ten photographic reproductions and correspondence concerning the manuscript." Eighty-five pages?! A whole manuscript, a finished article, a short book, that Tabarant wrote just on Victorine Meurent? This is it, goddammit! This is it. I knew there was a story here. It's obvious that Tabarant was more than mildly interested in Meurent; he had written about her on four different occasions. So there's a short book, is there, just about her? I open the folder. The précis? *Mais oui, bien sûr.* An eighty-five-page article with photographs? No! No article. No fucking article. It's gone!

"Excuse me, something seems to be missing here."

"Yes," says the brilliant, enthusiastic, able, and helpful librarian. "We know. It never was there. We don't know what happened to it."

YOU DON'T KNOW WHAT HAPPENED TO IT? YOU DON'T KNOW WHAT HAPPENED TO IT? YOU IDIOT, YOU STUPID IDIOT.

"Perhaps it's been misplaced," I venture, "and has been refiled in one of the other cartons."

"Maybe. You're welcome to look."

So I look. It takes two weeks. And I don't find the manuscript. On the last day, having gone through all the boxes, I sit at my parceled-out piece of library table absentmindedly fiddling with the précis. I am assailed by the usual volley of self-accusations: What am I looking for anyway? What does it matter? Who cares whether she lived or died? She's a nothing. She is no more Manet than she is Goeneutte. Forget it!

I know I'm still looking for a hero, and I'm not proud of it. Go ahead, deconstruct the boys, the artist-geniuses. Pick apart Picasso, Manet, Degas. But not Victorine Meurent. Oh, no, not Victorine Meurent. She has to be larger than life, and successful, a brilliant painter with lots of wonderful friends and lovers, a woman whose life was full of satisfaction and pleasure, a healthy, enduring woman who produced many paintings that have been spirited away by evil men, etc. As this tempest whips around me, my eye strays to the name in the top right-hand corner of the précis: Mina Curtiss. Mina Curtiss? Now, where have I heard that name before?

Oh, yes. When I was working on Degas years ago, I

came across Curtiss's edited and translated version of Daniel Halévy's *My Friend Degas*. Her lively, often snide commentary tickled me. I heard subsequently that Curtiss was supposed to be writing a study of Manet, perhaps Degas, too. On and off over the years I inquired about her and her work, but she disappeared. I thought she probably had never gotten to it, although I had this gnawing feeling that she was just another girl who had lost her steam. Nonetheless, she remained a friendly presence in my mind, another interesting woman's voice. And that was really it until I stumble across her at the Pierpont Morgan Library.

I pull myself up and approach the librarian's desk.

"Excuse me. Do you know who Mina Curtiss is?"

"Oh, the Tabarant papers were hers before they came to the library. I think there is an obituary in our files." Indeed there is, dated November 5, 1985:

> Mina Curtiss, an author, editor, translator, and teacher, died of a heart ailment Friday at Bridgeport (Conn.) Hospital. She was 89 years old and lived in Weston, Conn.
>
> Mrs. Curtiss was editor of a number of books, including *Letters of Marcel Proust, Olive, Cypress and Palm: An Anthology of Love and Death*, and *My Friend Degas*. She also wrote a biography, *Bizet and His World*, and in 1978 she published a memoir, *Other People's Letters*. . . .
>
> Her husband, Henry Tomlinson Curtiss, died in

1929. She is survived by two brothers, Lincoln Kirstein of New York City and George Kirstein of Mamaroneck, N.Y.

A bored inventory. The obligatory, occasional obituary of a woman. I find something much better, though, when I read John Leonard's review of Curtiss's *Other People's Letters* (1978):

> Where to begin? Mina Kirstein [Curtiss] began with brains, beauty, money, connections and a passion for reading other people's mail. . . . She was psychoanalyzed by Ernest Jones and fell in love with David Garnett. She knew the various "Bloomsburies." . . . Naturally, she worked on scripts with Orson Welles and John Houseman. . . . Of course, when she went to Iowa during World War II, it was with letters of introduction from the editor of *PM* and Carl Van Vechten. And who else but Edmund Wilson would have suggested to her that she translate Proust's letters? . . .
>
> But at the heart of the heart of the book, its aorta, is the Rumanian prince and successful French playwright Antoine Bibesco. He has a number of letters from Proust; Mina wants them; they meet. "I thought I was impotent," he tells her; "I have been for months. But you have roused me, you marvelous amazon." He wants to know how long since she has slept with anyone. "Four months," she says. "Ah, much too long," he replies. "I agreed," she

reports. He comes to her hotel room at the Ritz: "But you're not in bed," he complains: "All afternoon I've been picturing walking in and finding you waiting for me in bed." He declines brandy and cigarettes. She confides to her diary: "I must hand it to the Rumanians. Their idea of impotence in old age is the Anglo-Saxon notion of potency in the prime of life. And afterward he was delightful." She gets the letters.

At this moment in the narrative and in history, Antoine Bibesco is 69 years old, and Mina Curtiss is 50, and I am on the floor with tears in my eyes.

Now, that's more like it. Here's a woman after my own heart.

But why was this glamorous Mina interested enough in the largely uninteresting Tabarant papers to buy them? I go back over the contents of the boxes, particularly some correspondence I had not examined. This time I linger with letters between Mina Curtiss and a woman named Liliane Yacoel; the letters date from 1959 and 1960. Mina had just finished a book on Bizet and wrote to Yacoel, her assistant, that "I now have a piece of news that will surprise you. I have decided to write a biography of Édouard Manet. . . . He is my favorite painter" (October 3, 1958). She needed Tabarant's papers to proceed with her work. And perhaps like any very rich person turned to research, she decided to buy the papers.

Many of the letters between Mina and Yacoel concern dealings with a Mlle Lucienne Tabarant. She was the only child of the now-deceased art historian, and, it seems, in need of money. She had been dependent on her father, who had died nine years earlier at the age of eighty-seven, leaving his notes, a last, unpublished article, and some paintings, including a few said to be by Manet. To judge from the letters, Mlle Tabarant adored her father and had a very special wish she longed to fulfill for him. She desperately wanted his last article published. In the winter of 1948–49 the letters indicated he had written an eighty-five-page manuscript entitled—yes—"Celle qui fut l'*Olympia* de Manet." It turns out that Mlle Tabarant would *only* part with her father's notes *if* Madame Curtiss would agree to publish this long article.

Mina was not happy about it, but she agreed and proceeded to write an English précis of the article. Yacoel, in the meantime, consented, in Curtiss's name, to organize and inventory the Tabarant collection. It is her inventory that now facilitates the only access possible to Tabarant's papers at the Pierpont Morgan Library. Curtiss finished the précis and tried to sell the book to Gallimard in Paris and Pantheon in New York. Neither was interested. She felt acquitted of her responsibilities to Mlle Tabarant and let her true feelings rip in her letters to Liliane:

> I am sure you will be amused by the enclosed copy of Goldschmidt's appraisal of Mlle T.'s books. I had

thought that she was overcharging me about a thousand per cent. . . . I do think that she has behaved absolutely digustingly, after all her talk about *"une grande dame à une autre."* [August 24, 1960]

I get in touch with Gallimard and Pantheon in New York and Paris. They have no record of the discussion at all, no manuscript hidden in an old file cabinet. Where the hell is the manuscript? I reread the Curtiss obituary. I start thinking about Curtiss's estate and about getting in touch with her brother, Lincoln Kirstein, the great ballet impresario and poet. Then a friend of Ken's at the Wildenstein Gallery says to me, "Did you know that Mina Curtiss left all her papers to Smith College?"

Ken and I are going to a town on the Massachusetts coast to stay with Ken's sweet three-year-old nephew, Wren, for a month. I plan to make an excursion to Smith for a few days. I take a bus to Cambridge on Wednesday morning and then one to Northampton arriving at about 2:30 P.M. I go with my luggage straight to the Sophia Smith Collection, a women's history archive. Since they are closed on the weekends, I only have two and a half days to examine the Curtiss material. I have two librarians' names handy from phone conversations. They know about my specific interest in Mina Curtiss's papers.

I walk into a spacious, bright room of light wood and tall windows—a beautiful, welcoming, peaceful room. A young woman rises to help me immediately.

"Oh, yes, Ms. Lipton, we were waiting for you.

Please, let me put your bags on the side. Why don't you just sit down here, and we'll bring you the inventory of Mrs. Curtiss's papers. We have also taken the liberty of bringing up some material that we thought might be of interest to you."

"Thank you so much. You're so kind." I am practically in tears.

And so it starts. I look through miles of papers. Indeed, I find Mina Curtiss extremely engaging. She was a rich Jewish girl who had gone to Smith during World War I, graduating in 1918. At school, she was an ardent socialist and made fun of mercilessly—her money, I'm sure, being her cross at the time. She could certainly take the needling; she was one tough tootsie. She took a B.A. in English, which she quickly followed with an M.A. at Columbia in 1920. She returned to Smith that same year to be a professor of literature and taught on and off until 1934. In the early twenties she married Henry Curtiss, who died in 1929. She never remarried.

Curtiss was a woman who spent her riches easily and lived high with the most glamorous and intelligent people in North America, Britain, and France. She loved to eat and to talk. She was a voracious reader and relished being in the middle of other people's business; she was an avid collector of letters. She wrote many articles and reviews, and several books. Among them are *A Forgotten Empress: Anna Ivanovna and Her Era, 1730–1740* (1974) and finally *Other People's Letters: A Memoir* (1978). Of all the work, *A Forgotten Empress* strikes me as the oddest. It is about a coarse Russian ruler of the eight-

eenth century whose appetites nonetheless included theater, musical entertainment, and ballet. Curtiss draws a picture of a sensual, self-serving middle-aged woman who wields power as well as influence. I see that Curtiss was drawn to peculiar and compelling women. Why not Victorine?

Curtiss was ambitious and, it seems to me, ambivalent. For a person who never appeared to curtail her own pleasures, she was enormously productive, but she was also either uninterested or unable to develop strong arguments in her writing. Her observations were astute and her writing lively, but in my opinion she never went far enough. She wrote like a privileged amateur, a rich person entertaining herself.

For two days I journey through her life, and enjoy it. I almost forget Victorine, although I wonder if Mina had red hair. By late Friday afternoon, I have not found the manuscript, and I am not feeling well. I am on the last two boxes, the two cartons marked "Miscellaneous." I've postponed them, because they seem so inconsequential, filled as they are with correspondence between people I've never heard of. I sit at the table tired and discouraged, dutifully opening and closing letters. I pause, my mind wandering, when out of the haze of heat and depression I notice the name Liliane. The letter I hold is from Francis Steegmuller and dated January 8, 1978; it was in the Houghton-Mifflin folder. Steegmuller had been asked by the publisher to peruse Mina's manuscript *Other People's Letters*. Apropos of the credits, Steegmuller noted that "Mme 'Liliana' Ziegel

should of course be Liliane, as elsewhere. Ziegel . . . once asked me to refer to her as Mme Olivier Ziegel. . . ."

Liliane—not a very ordinary name, I think. Maybe Liliane Yacoel got married. In addition, "Liliane," "Yacoel," and "Ziegel" all strike me as Jewish names. I jot down "Mme Olivier Ziegel" and close the Houghton-Mifflin folder, and this first of the miscellaneous boxes as well. I start on the second, and last; it's packed with correspondence. Near the bottom is a bulging manila folder. It bears the label "Ziegel, Liliane." And it is filled with letters to . . . Liliane Yacoel! Fifteen of them are about the Victorine Meurent manuscript.

Back and forth Liliane and Mina go on the subject. Mlle Tabarant is apparently in a nervous state about everything. She has fainting spells; she can't come to the door; she says she won't part with the manuscript. Then she insists on its publication before any other transaction is made. Then she's deathly ill again. Mina writes to Liliane:

> Believe me, Liliane, Mlle T. will forget all about that manuscript after I've bought the rest of the papers from her; what she wants is the money. Don't worry yourself about her so much. . . . [August 24, 1960]

Mlle T. taunts the two researchers with her "Papa's secret papers." The manuscript flies between the women.
Mina to Mlle Tabarant:

If you would still like me to translate your father's work on Victorine Meurent, and concern myself with its publication, it is indispensable that I am made familiar with the manuscript.... [April 22, 1959]

Mina to Liliane:

You can use your own judgment about when you return the monograph to her. [August 28, 1959]

As to the Victorine Meurent manuscript, I think the thing to do is to hold on to it until after she has either sold some pictures to [Mr. X] or I have bought the collection. By then she will have enough money, I hope, to put *le gloire de Papa* in the shade a little. [September 15, 1959]

Liliane to Mina:

Concerning the Victorine Meurent I know that the simplest thing is to return it to Mlle T. but up to now she has refused to take it back. [January 20, 1960]

I haven't sent you the Victorine Meurent manuscript. Should I return it to Mlle Tabarant or do you want me to send it to you by normal mail? [February 19, 1960]

How I wish I could fit myself neatly in between these letters, jump between the twirling ropes, and grab the manuscript. Instead, it vanishes.

Smith was my last hope. Before leaving on Friday, I try to chat amiably with the librarians. They're so disappointed. One of them, trying to be optimistic, says, "Why don't you contact Lynne Robbins? She was Mina Curtiss's last assistant and executor of her estate. Maybe she'll have some ideas." I return to Cambridge drained, with a pack of photocopies and Lynne Robbins's phone number. I don't call her for two days; I'm tired of the roller coaster. When I do call, she is kind and helpful and says, "Write to Liliane. She's very much still around, and she adored Mrs. Curtiss. Tell her how much you admire her, too, and she'll be glad to help you."

Liliane is alive? It never occurred to me. Immediately I write a polite and enthusiastic letter—about my work, but more about Mrs. Curtiss. I tell Mme Ziegel that I am embarrassed by how much I know about her, having read her personal and professional correspondence. She responds, shy and interested, clearly a strong and proud woman. And stubborn, I feel, too. She writes, "I do not remember this manuscript you mention, but I will look through my files. It will take a little time, because Olivier [her husband] has to go down to the cellar and bring up the cartons." Two and a half weeks later, another letter. "No, I'm sorry, I do not have that manuscript, but I too found references to it in my files. Have you contacted Mlle Tabarant?"

"No, I haven't," I write back. "She seemed so sickly

from your letters of 1959 that I simply assumed she was
dead."

"Well, why don't we find out? I'll just go by her flat
and talk to the concierge; I know her."

She knows her? You can see how easily Liliane falls
into the search. She's an expert. I love experts. During
the almost forty years she worked for Mina, Liliane was
introduced to many British and American writers and
scholars who relied on her expertise. I had learned from
the Curtiss papers that Liliane was of such great help
to them that she had been recommended for a national
French honor.

A week later, a telephone call.

"Madame Lipton? Mademoiselle Tabarant is alive.
She is very weak and will not come to the door, or an-
swer the phone. What would you like me to do? I could
write to her, or you could. Or a bit of both. I could
accompany your letter with one of my own introducing
you as well as a translation of your letter."

This is the first time I hear Liliane's voice—the
timbre, the cadence—it's high, kind, efficient; her En-
glish is perfect.

"The latter, I think. I'll send you a letter tomorrow
with a gift of my book on Degas that you might give
Mademoiselle Tabarant."

A phone call the following week. "She has the man-
uscript. I've photocopied it for you."

"No. I can't believe it! You have the manuscript?
I'll be right there."

• • •

A month later, mid-December 1988, Ken and I board an Air France jet for Paris and have the worst trip of our lives. For two solid hours with no word from the cockpit and frightened stewardesses sliding down the aisles clutching each other, the plane shakes like a carton in the stratosphere. At the peak of turbulence, my neighbor, an immense Egyptian of about fifty-five, encloses my hand in his. He has moored me to the universe. We don't look at each other, and we don't speak, but we land safely.

We arrive in Paris, and make a tight fit into a tiny *chambre de bonne* in the Fifteenth Arrondissement. I call Liliane.

"Come for tea tomorrow with your husband. I have the manuscript for you."

The next day Ken and I are welcomed into a palatial apartment in the Sixteenth Arrondissement near place Victor Hugo in the vicinity of Étoile. A beautiful, white-haired Liliane and an equally handsome Olivier answer the door. She is so familiar to me, an elegant Jewish woman of a certain age; strong, but also easily hurt. Him I don't know—magisterial and kind, a mix of De Gaulle and Albert Schweitzer, about seventy-eight. We are escorted into a large, overstuffed living room, and invited to make ourselves comfortable. I sit next to Liliane on the couch. She hands me the manuscript, and turns to the others, offering drinks and sweets. I page through Tabarant's book. Even now I know I'm not sup-

posed to be *that* interested, *that* excited. I probably shouldn't even be looking at the manuscript. I pore over it, trying not to appear frantic. Almost immediately, I see that there are no footnotes, no "proof"; that the style is the flamboyant, amateur's style typical of Tabarant and generations of gentlemen who became scholars. As I turn the pages, some drawn forms resembling labels catch my eye, but I don't stop. My heart sinks slowly. I understand that there is nothing new here; it replicates what all the men said and Goeneutte painted. I look up, smile, drink some whiskey.

"Thank you."

Olivier and Liliane are enjoying Ken, who's showing them transparencies of his work. Included are some paintings in which he used nineteenth-century military uniforms. Olivier is transfixed; we didn't know that he had received the Legion of Honor for his service in the Resistance during World War II. Ken delights in the attention; he is drawn to older men.

We go back to our tiny room.

"So," says Ken, worried.

"It doesn't look good."

I leaf through the pages again that night. I don't actually read the manuscript for another year. It's the same old story. Inexorably, it pulls you into the folds of a miserable life of degradation, poverty, and humiliation. I bundle it away into its folder and shelve it. I can't stand the sight of it. She *had* no life, she *was* a nothing.

. . .

I turn my back on Victorine and do other work—a long essay on Boucher's luscious women, another on multiculturalism in the arts, some pieces on women artists. The following fall I am invited to participate in a symposium at the Whitney Museum of American Art entitled "Marxism and Feminism: Convergence in Art." They want me to talk about the two "isms" in relation to my work. I fiddle at my computer for a while, trying to figure out what to say. The project bores me completely. It's two days before the symposium, and I'm at my wit's end. Finally, as a lark, I start writing as if I were Victorine. She's talking. Out of nowhere. I hear Ken coming from his studio.

"Listen to this." I laugh nervously.

His mouth drops open.

"Eun, this is great. You're really on to something. You going to use it at the Whitney?"

"Are you crazy?"

"Why not? You're not a professor anymore. You can do what you want."

And that's what I do. It's a cool November evening the night of the symposium, and we're below stairs in the cafeteria looking out at the sculpture garden and autumn in New York. After a number of serious paragraphs on Marxism and feminism and comments on how George Bush won the last election off the back of Willie Horton, I pause suggestively and start my story: "There was a woman who lived in Paris at the end of the nine-

teenth century. She was Édouard Manet's model and a painter. She posed for *Olympia* and the *Déjeuner sur l'herbe* and other paintings. Her name was Victorine Meurent. When Manet wanted to begin work on his painting *Olympia*, Meurent said this to him: 'Come now, Édouard, you don't really want me in that pose, do you? You with all your ridiculing of academic art and empty-headed Venuses? And, Édouard, when will you pose for me? . . . Well, all right, but I'm going to do it my way.' "

The audience loves it, and I never enjoyed performing so much in my life.

Now I return to the Tabarant manuscript and read it entirely. This time it fascinates me, not because there is any new slant, any ideological or imaginative shift, but because Victorine, for the first time in a hundred years, is materializing in new places. Her hands brush unexpected surfaces, she steps across unfamiliar thresholds. New voices are talking about her. These voices are quoted directly out of the intimacy of conversations with Tabarant, who now feels very familiar to me. I know his secret: He was obsessed with Meurent.

He describes her as "moody" and also as "the kind of person who by nature excited commentary." He quotes Manet's stepson Léon Koella Leenhoff as saying, "When she wasn't degraded by alcohol, she had immense charm; she was extremely alluring." However, Leenhoff proceeds to describe her in the winter of 1882–83 as "unrecognizable, she looked deathly." She had come asking money of him at his office at 1, rue Nouvelle, at the corner of rue de Clichy, where he was a stock-

broker. "Only her breasts seemed unchanged," he said.

In the same patronizing voice we hear Louis Gauthier-Lathuille tell Tabarant that he saw Meurent near the 1889 World's Fair. She was "on the avenue de Suffren. She was seated on the ground, leaning against a wall, strumming a guitar. I didn't recognize her for a long time, and then I couldn't believe my eyes. She was dressed in rags, her hair was white, she was very old." (Meurent was forty-five at the time.)

Suzanne Valadon further testifies to Meurent's degradation. Tabarant writes, "Valadon locates her first vision of Meurent between 1885 and 1886, that she was a painter who had formerly posed for painters. Everybody knew her. 'Here's La Glu, they'd say.' (It's Valadon who is speaking.) 'I see her again, very straight, dressed in light colors, not at all showy. She was said to be proud and not talkative. . . . It was in 1886 that she could be seen in the evenings at the Élysées-Montmartre as a so-called artist. In 1887 she was quite simply a whore. . . .' Valadon also remembered that suddenly this exclamation had circulated, and this question, 'Hey! We don't see La Glu anymore. What's become of her?' Toward the middle of 1888, no more Victorine."

A crucial piece of the story that clearly troubles Tabarant is the Marie Pellegrin episode. He writes that Marie Pellegrin, a well-known courtesan, "saw her and threw herself into Victorine's arms, embracing her intensely—a romance intensified by drunkenness. She swore, she made Victorine swear, that they would never separate again. . . . She moved in with Victorine. One,

boulevard de Clichy, the third floor, became the ren-
dezvous of a certain kind of street girl, and kept woman,
as well as of girls who simply desired other girls, and
day and night the house shook with laughter and yelling;
there was never any peace among the women, who em-
braced and pulled out each other's hair at the same
time."

Tabarant couldn't forget the image of the two
women together. Next to the last page of his manuscript
he admits, "Can I pass 1, boulevard de Clichy, without
pausing sadly as I look at that humble three-storey fa-
çade . . . ? My thoughts dwell on the bay window of the
third floor that opened onto Victorine's room, where in
1877–1878 she made a common bed with Marie Pelle-
grin."

The saddest part for Tabarant was the calling cards,
les bristols, that Meurent used in local cafés and dance
halls. He writes, "Victorine made some cards—Léon
Koella [Leenhoff] had one of them—on which in her
most beautiful handwriting she wrote:

Victorine-Louise Meurent,
exhibiting artist at the Palais de l'Industrie,
invites you to look at her drawings.
Thank you!"

When things got even worse, Tabarant wrote, she
made up another card "which Léon Koella also had. It
said:

———————————————

Victorine-Louise Meurent,
exhibiting artist at the Palais de l'Industrie.
I am Olympia,
the subject of M. Manet's celebrated painting.
I invite you to look at this drawing.
Thank you!"

It was these cards, drawn schematically in the manuscript, that I noticed at Liliane's that afternoon in Paris. I'm sure it was a primary reason why I postponed reading the manuscript for so long. I couldn't stand the thought that Meurent's identity was so completely bound up with Manet's and in an event that had occurred twenty-five years in her past. *And* that she was peddling that relationship. Now the cards look like part of a resourceful woman's strategy to make money. Just what the graphologist said: "She had a good sense of money and knew how to turn a profit."

Near the end of the manuscript, Tabarant writes, "The last trace I had of her was in 1892. After that, it's anybody's guess. . . . Opinions that I have obtained from wise old experts agree that she died toward '92."

Tabarant admits to repressing all this information in his 1947 *Manet et ses oeuvres:* "I stopped myself, terrified, on the edge of the abyss that I had discovered. . . . [In the present essay] I descended. Imposing on myself the task of evoking Victorine Meurent in all her guises, completely, I straightforwardly dealt with this up until now vague, alluring, and offensive heroine.

I have emphatically unrolled the account of that life of damnation that brought everything to disaster."

It is remarkable how blinkered Tabarant's vision was. On the one hand he prided himself on his knowledge of the art world and its gossip. He knew everybody, he said—the painters, their friends and lovers, their dealers, their haunts. On the other hand, he didn't know that Meurent became a member of the Société des Artistes Français in 1903, that she exhibited at the Société's Salon in 1904 and received money from them in 1909 and again during World War I. And, finally, that she lived until 1928.

Tabarant first published an article on Meurent, interestingly also entitled "Celle qui fut 'l'Olympia,' " in 1921 in the *Bulletin de la Vie Artistique*. At that moment, she was still alive, walking around, probably somewhere in Paris. Why didn't he know this? What prevented him from knowing this? And thirty years later, he writes near the end of his eighty-five-page manuscript, "[In the early 1890s] would the police have thrown her in jail for begging? . . . Trespassing? . . . Opinions about things can arrive long after the fact. . . . A generation passed, an entire generation. And it was hard to find survivors. . . . My fears and my dreams were attached to the café Nouvelles Athènes. If some story had contained the name Victorine Meurent, I would have heard it. I will add that learning of the demise of La Glu wasn't in the forefront of the minds of regulars at the café, although the Nouvelles Athènes had its gossip mongers for stories

about the art world. Everything that touched Manet had its particular audience. . . ."

The answer to why Tabarant didn't know that Victorine was alive and well in the 1890s is that his point of reference was an art world in which she did not live, and with which she had only occasionally rubbed shoulders. His vision was riveted to one vanishing point on a particular horizon, and that was the story of avant-garde art. Victorine Meurent lived in another system of reference, in a narrative as yet unformulated and uncodified, but not uninhabited. Tabarant's art world did not encompass the Société des Artistes Français or artists like Gérôme, Bastien-Lepage, Robert-Fleury, or part-time artists, or artists who had to sell their work in order to live and performed these negotiations matter-of-factly. In the lexicon of the avant-garde art world, Meurent could not have figured as an artist. None of this means she was not an artist. It just means that her life was invisible to writers like Tabarant. For some reason this invisibility makes me think of my mother.

Recently, I admitted to an old friend the extent of my mother's cruelty to me. My friend, a wise and tender woman and a mother herself, listened patiently, and then very quietly said, "Remember, Eunice, whatever else our mothers have been, they were all once eighteen."

Why is she saying this to me? What, am I supposed to forgive Trudy now? I don't want to forgive her. Why should I? But as Linda—this second Linda whom I know

from childhood—summons my mother's life in this way, I fall silent; I can no longer hear what she is saying. My mother stands there looking at me, wistfully. She's day-dreaming. Her fat body tapers to a young woman's curves, the crisp edges of her fantasies—the whites and reds of freshly starched skirts and blouses, blue skies, sex, and freedom—call to me.

How did Trudy lose her life?

Why did Trudy leave me? Why did she hate me so? She said she had to work. There was the story about her mother's death and her own depression. I don't know, I don't remember my grandma Tillie or what happened afterwards to Trudy. My mother said she loved her mother, but she always told the same story:"When my mother died, I bent over the casket to kiss her good-bye, and when my lips touched her face, I realized how rarely we had kissed." Trudy always cried when she remembered this, but it never made her think that she never kissed me.

I don't think my mother left because of her mother's death. I'm sorry I don't believe her, but I don't. I know why she left. My mama loved to dance, and she was good at it. She was quite a talker, too; she could strike up a conversation with anybody and have a good time. And she'd always worked—at the five-and-dime when she was a girl, and as a bookkeeper later on. She smiled a lot and laughed, she was full of easy joy; people liked her. Her lips were full and red, her body round, her long legs shapely. She had a friendly word for everyone, and she did not disdain the attention of men. My mother

didn't want to hear a baby crying or feel a little hand grabbing after her. She wanted the adventure of the stroll, the lilt of the fox trot, the wind in her hair on autumn days. My mother wanted to be swinging down Tremont Avenue heading to the Loews, or sipping an ice cream soda at Sutter's with her long legs gracefully wrapped around the counter stool, or just feeling her body wandering the boulevards. My mother wanted what I want—an adventure, pleasure. But marriage was my mother's only choice, and marriage broke her spirit. The fatal blow fell when she had me, her first child. So, when the chance came to get rid of me, she took it. She hoped the old Trudy would come back. I hope she did.

Tabarant and I are not the only people who have been drawn to Victorine. When I published a book review in *The New York Times* in 1988 that mentioned I was working on her, a number of people wrote or called me. First I heard from an eccentric young playwright who told me she was psychic and that she was writing a musical about Meurent, whom she found "very positive." She also found Meurent street-smart and resourceful about money, though she was sorry about her drinking problems, which she, the playwright, knew plenty about personally.

Then there was Otto Friedrich, the well-known nonfiction writer who wrote to me:

> In the spring of 1980 I went to Paris with the vague idea of writing a book about Rossini. . . . Instead, I

found Victorine Meurent, in her black ribbon and her orchid and her bracelet and her blue slipper, almost demanding that a book be written about her. . . . In [the *Times* of July 17] I read the inevitable news, that somebody else heard Victorine's demand. . . . It's like finding footprints on what one had thought was an empty beach. Today [August 16, 1988] I was rummaging around in the Morgan Library when I came across a reference to Adolphe Tabarant's 85-page manuscript. . . . I pointed out this reference . . . to the librarian, hoping to see it or even Xerox it, but she promptly said that the library didn't have it, and that somebody else had been asking about it recently. When I asked for this other searcher's name, it was, of course, yours.

Finally, in the midst of my own work I read a dissertation by Margaret Seibert, "A Biography of Victorine-Louise Meurent and Her Role in the Art of Édouard Manet." Seibert's interest was in salvaging the individual, Victorine Meurent, from Manet's paintings by reading a biographical narrative into his work. For example, she points out that Meurent was a guitar player and depicted that way in Manet's *The Street Singer*; that Meurent was a courtesan or working girl of easy virtue— and represented as such in Manet's *Déjeuner sur l'herbe* and *Olympia*; that Meurent was an actress and Manet paints her as *Victorine in the Costume of an Espada*. In passing, Seibert notes that Meurent was a painter.

. . .

I complete a draft of this manuscript in the spring of 1990 in New York. By this point, I know it is about both Victorine Meurent and me, what became of her, what is becoming of me. I give up trying to find more concrete material. I've done what I can in the States, and I have found the Tabarant manuscript. I have also checked steamship passenger lists of the 1860s and census reports and found no trace of Meurent's trip to America. Maybe she never came. She seemed perfectly capable of making up the story; traveling to America was a romantic thing to do in the 1860s and seventies. Degas had done it. So had Manet's friend, the opera singer Émilie Ambre. So, too, the art dealer Durand-Ruel, and Sarah Bernhardt would in the eighties. The trip nags at me, though. All the more so when I remember that six of the nine paintings Manet made of Meurent are in the States. There is also that American who wrote to Durand-Ruel in the thirties inquiring after her.

The End

When I return to Paris in August of 1990, I think it is simply to write my book amidst those streets and that language, that pleasure and permissiveness which Paris is for so many Americans. I have no intention of doing more research. There is only one little chore I think I will pursue for nostalgia's sake: I will go back to the office of the Société des Artistes Français and try to locate the original of the photocopy I found at the Musée d'Orsay. After all, it was that "died 1928" that set me going in the first place. In the back of my mind I think that if I find that document, I may also find some information about why Meurent received money from the Société. I am not optimistic.

It is a sunny late September morning when I enter through Porte H at the Grand Palais and knock at the

Société's door. A sweet feminine voice calls *"Entrez."* The room is empty except for the owner of the voice, a motherly-looking woman of about sixty. She rises from her desk, which bears the name plate "Mme Berthier," smiling.

I tell her my story. Growing visibly agitated and apologetic, she says, "I am the only one who works here now, madame, and to be quite frank, I haven't the faintest idea what is in all the drawers and files. I wish I did. I'm afraid that the last person who knew died last year."

Well, I met that particular expert three years earlier, and with all due respect for the dead, this woman looks much more promising. I ask if I can take a look around. She says, of course, and that while I do, she will look for the Salon listing I want.

There isn't much to browse, just some dusty folders of people's work dating back to the 1950s. I notice, however, in the corner of the room about sixty volumes of what turn out to be the minutes of the Société dating to the mid-nineteenth century. I clear off a long table on the far side of the room under a window, and fall to perusing the minutes, thinking there may be some information on what determined to whom the Société gave money. Without much difficulty, I find notices of who contributed funds for members' needs and extensive notes on retirement costs, but no discussion of why certain people received money, and no mention at all of who received it. I suppose it was discretion.

Turning the yellowed pages, I am brought up short

by this piece of information: In order for a person to become a Sociétaire, he or she had to be presented to the Société by two members. Two members? Everyone needed two members? And who, dear God, presented Victorine Meurent? What real person of obvious authority found my dear Victorine a deserving candidate? Thrilling to the hunt and poised for victory this time, I dash back through the minutes, searching for 1903. And there on page ninety-four, I read: "The subcommittee passes on the admission of Mlle Meurent (Victorine), painter, presented by MM. Hermann-Léon and Tony Robert-Fleury." Robert-Fleury was no less than the director and founder of the Société; Charles Hermann-Léon was a respected animal painter. I remember then that Meurent lived on the same street as Robert-Fleury in the 1890s, if not in the same building, at 69, rue Douai. So, at the age of fifty-nine Meurent, who had left "profession" blank on her birth certificate, was a serious-enough artist to be admitted to this organization and by two reputable artists.

In the meantime Mme Berthier puts her hands on the original exhibition list—a modest piece of aged cardboard, about nine by six inches in size and turned a beautiful pearly-peach color—listing all of Victorine's exhibits and containing the old-fashioned, handwritten letters that say *"décédée, 1928."* I feel like kissing it. I ask if I can take it outside to photograph in daylight. Of course, says Mme Berthier.

I try to prop the document on the slanting stone

parapet just outside Porte H, and I make about twenty-five photographs, none of which, I later discover, comes out quite right. As I am photographing I look up and across the street at the Petit Palais and I remember the beautiful Courbets there—particularly *The Sleepers*—the two voluptuous naked women asleep on a queenly bed. I think of Linda's fascination with Courbet, but more I think of what a mentor she has been to me.

I return to the office about as serene as I get and continue poring over the minutes. The next thing I find are periodic listings of current members with their present addresses. A strange stillness pours through me. I know that any second now, I'm going to find Meurent's address, and I'm going to know why I couldn't locate her death certificate in all the arrondissements of Paris. I'm going to know that she really existed somewhere all those years. I'm going to know that she made paintings, that she was an artist, that maybe—*maybe*—there were even paintings somewhere, right now! And then, there it is, right in front of me: In 1906 the Sociétaire, Victorine Meurent, lived at 22, rue Clara-Lemoine, Colombes. The year after and through 1922 that same Sociétaire is listed at 6, avenue Marie-Thérèse, Colombes. Her name disappears in the records of 1927–1928.

"Madame Berthier?" This time I just call across the room. "Where's Colombes?"

"Oh, madame, it's quite close. It's a suburb just to the northwest of Paris." It is as if we are yelling across our backyard fences, exactly what Virginia Woolf

thought the British could never do and the Greeks always did and why the English would never properly understand Greek tragedy.

Two days later I go to Colombes, a ten-minute train ride from Saint-Lazare station. As the train jogs toward what I know, but am too superstitious to admit, will be Victorine's home, I read a letter that had fallen to the bottom of my briefcase. In it I learn from a scholar working on the Académie Julian that she just came across the following entry in a newly opened archive about women students at the academy: "1875–76, Meurent, Victorine, evening classes." Further, she writes, it was unusual to be given the first name of the student.

In Colombes I of course find Meurent's death certificate. I knew I would. I wait calmly as the clerk searches for it. I idly examine the red, yellow, and white map of the town on the wall and find not one but two streets called avenue Marie-Thérèse. The clerk returns and hands me the death certificate. It was written for a Victorine Meurent (no middle name), who had died at 6, avenue Marie-Thérèse, on March 17, 1927, at 7:00 P.M. The certificate says she was unmarried (*célibataire*) and without profession (*sans profession*).

Nineteen-twenty-seven? The handwritten *"décédée, 1928"* had been false after all? Just the product of hearsay like so much else about Meurent? It doesn't matter. The handwritten "1928" indicates that Meurent was a subject of gossip in the late twenties. I can hear the bantering in the office: *"Eh, dis-donc!* Have you heard

that Victorine Meurent died? It was early in nineteen-twenty-eight." A clerical worker answered with a wink and entered the date in the record. Just like that.

A number of clerks in État-Civil are interested at this point, and one says, "You should go upstairs and talk with Madame Roger, our local historian. She knows everything about Colombes. She'll be able to help you." Up I go. Mme Roger is taken by the story and says, "Let's look up the address." She pulls down the old familiar giant tomes that house so much crucial social data in France. These list Colombes citizens by address. The volumes comprise a kind of census and were compiled every five years. Each page is divided into columns designating age, place of birth, occupation, and relation to the head of the household. The first volume we look at is for 1926. Mme Roger locates the address, and the people who lived there. Before I know who they are, I am surprised by the number. Being a New Yorker, I always assume people live in apartment buildings, so I am expecting at least twenty-five families, allowing for the smaller size of a French building. Victorine lived at 6, avenue Marie-Thérèse, with just one other person, a woman by the name of Marie Dufour. There are columns for location of birth, age, profession, family relationship—wife, mother, son, daughter, occasionally "*sans*"—no relation. Both women are listed as having been born in Paris. Dufour is the younger by eleven years; she was seventy, Meurent eighty-one. Dufour is listed as the "*chef*," the head of the household; Meurent

as "*amie*," woman friend. No one else entered the word "friend." Never have I felt Meurent's life so poignantly.

Searching through these books I see that in 1906, Meurent listed her profession as "*artiste-peintre*" (artist-painter). This is the first written evidence I've found that says she considered herself an artist. Dufour entered nothing. In 1911, Meurent again called herself artist-painter, and this time Dufour said she was a secretary. In 1921 Meurent still identified herself as an artist—she was seventy-seven years old—and Dufour said she was a piano teacher. They alternated calling themselves "*chef*"; perhaps they owned the house jointly. The books indicated that they lived together from 1906 to 1926— for one year at 22, rue Clara-Lemoine, and the rest at 6, avenue Marie-Thérèse.

Were they lovers? I think so. I hope so.

Mme Roger tells me that in the late nineteenth and early twentieth centuries many artists lived in Dufour and Meurent's neighborhood.

I met Marie about the time I met Ida Bauer, around 1898; I was fifty-four years old, she was forty-three. We were ushers in the same theater. She was a very contemporary type of person. She knew all the latest songs and singers, the good places to go. Although I always hated the writing of Colette's husband, Gauthier-Villars—Willy, you know—I can understand why he called

his column about music in *La Revue Blanche* "Letter from an Usher." We were full of opinions; nobody tips a taciturn usher.

Marie was kind, not like other lovers I'd had. Not that she wasn't charming or lovely, but there was something solid about her. I knew I would always be able to count on her. It is she who suggested in 1906 that we move to the country. She said she could get work teaching the piano or doing secretarial jobs, and I could paint. Then we heard about retirement possibilities for artists in the suburbs, especially in a town called Colombes. We went out there and looked at some houses. There was a very small one on the avenue Marie-Thérèse that would be available the following year. We got the money back that we'd put down for our usher jobs and moved. Lautrec was dead, and I admit I didn't go searching for Robert-Fleury to return his money. Marie also suggested seeing if the Société des Artistes Français might not give me some financial assistance. She reminded me that being a member made me eligible. And don't you know if they didn't give me money twice. Not right away, but in 1909 and during the Great War. And one was the sizable sum of 1,773 francs.

It was a good time to leave, 1906. I remember passing the Élysées-Montmartre on Rochechouart and seeing the new corner entrance going up. I had spent many a night there during good times and bad, dancing with Janine, drinking with Julie and Lautrec, selling my work. And it's there I had the row with Valadon; it was

**because of her I had to stop going. *Quand même*, it was
a place to be in its time. Gone now was the huge garden
café, the sprawl of tables, the mix of people. The new
façade was flamboyant, rococo—the style they were
calling *art nouveau*. Not to my taste.**

Two women together, one an artist, the other artis-
tic. Both resourceful. There were plenty of stories about
women like that, women who had been actresses, dan-
cers, musicians, but who hadn't made it to the top,
hadn't found or looked for rich protectors. Some of the
best and most reliable stories are told by Colette. In both
The Vagabond and *The Pure and the Impure* she evokes
the world of women entertainers—raucous drinkers and
conversationalists, lesbian love affairs, master players
of the Tarot cards. Colette reminisces:

> An actress acquaintance, Amalia X, a former com-
> panion of mine on theatrical tours . . . if one were
> to believe her, had not hesitated to leave a sleeping
> and satiated sultan and go on foot, veiled, through
> the night streets of Constantinople to a hotel room
> where a sweet, blond, and very young woman was
> waiting up for her. . . .

While on tour with a show Colette describes a dinner in
the provinces:

We have just dined at Berthoux's—an *artistes'* restaurant. . . . Barally [an old actress] . . . has laughed so much, showing her beautiful teeth, and talked so much, relating terrific binges when she was young. . . . She tells us of the colonial theaters of twenty years ago, when she used to sing in operetta in Saigon, in a hall lit by eight hundred oil lamps. Penniless and already old, she is the old-fashioned bohemian incarnate, likable and incorrigible.

Living in Colombes was pleasant. So many trees, fresh air, people I didn't know. Such a change from Paris.

I stopped working for a living when we moved there. I never had such freedom before, and I hadn't known the life, the emotional life, that goes with it. I worried that I became more difficult to live with. I'd get so moody. Marie said no, just more interesting.

My work changed. I began painting contemporary life. Not scenes with figures, but landscapes and still-lifes. One afternoon, late in the day, I walked into the fields out beyond our house. I took a small canvas and some charcoal. The sun hung low in the sky; it covered Minot's farm with a golden hue as it did the trees and pond—browns, golds, whites, blacks. You don't see colors like that in Paris; you don't see the sun go down. I made a sketch—the horizon, the thatched roof, something to remind me of the greens gone brown and yellow. I sat, maybe for too long, just looking.

When I came home, Marie was sleeping. I laid in the colors and put up a pot of coffee.

After chatting with Mme Roger, I decide to go back downstairs to État-Civil to see if I can find out where the two women are buried. I want to visit Victorine's grave. I find them listed in the cemetery record: Victorine Meurent in the volume for 1927, Marie Dufour for 1932. I feel a pang for Dufour's surviving Victorine by five years. Both graves are gone. The women had died indigent; neither had relatives. There was no *succession*, no legacy—no paintings to find; there was no bureaucratic record of what they left. They left nothing. And, of course, now I really want to find the paintings in a way I never have before.

Well, at least I can stroll over to where she lived. Mme Roger gives me a map, and indicates the best route. Maybe I'll knock on a few doors, search a few basements.

I walk for half an hour. I turn on to rue Tilly, and two steps later I am staring down a narrow sidewalk lined on the right with three houses. Nailed to a brick wall is a rusted street sign that says "Marie-Thérèse." But it is crossed out and below it are shiny enameled numbers: "5," "5*bis*," "5*ter*," all referring to rue Tilly. There is no number 6, and there is no avenue Marie-Thérèse. This at least explains why I saw two streets with the same name on the map; one is no longer extant, rather like Meurent. Well, I'm here, I might as well look around; I'll feel like shit if I don't. I must look odd,

though, because I am soon aware of someone watching me. I turn to find a short, squarish woman of about thirty-five in a plain blue dress and white apron. Kids are swarming all around, every once in a while stopping and staring at me.

I introduce myself as an American writer looking for an artist who once lived here, when it was avenue Marie-Thérèse.

"Oh, it hasn't been that for a long time," says the woman.

"*Oui*," I agree. Why I ask her the next question, I'm sure I don't know: "Which house do you think was number 6 when it was Marie-Thérèse?" She has no idea. I don't want to leave and decide for no apparent reason that number 6 is the house at the end of the sidewalked path. I ask the woman if she perchance knows who lives there. She says yes, but that they have been residents for only a little while, meaning, I suppose, that they will be of no help to me. "Could you introduce me?" Reluctantly, and it seems to me, impatiently, she cups her hand and calls, "MADAME DRONIOU! MADAME DRONIOU!"

A nervous little head pops out of the window facing us, talking fast and smiling. It belongs to a woman in her early thirties. I walk up to the window and introduce myself and say some general things about Meurent: She is Manet's Olympia, but she was also an artist, she lived on this street, etc. The bobbing head says, Come in, come in. I'm busy and rushing, but come in, come in.

It is a small, compact house made of concrete. The windows have white shutters. Entering, I walk down a

narrow hall through a square, small kitchen into a marginally larger dining area. The windows are set high in the wall; there's not a lot of light. It has all the necessary furniture. More kids are buzzing around and also pausing from time to time to eye me. Mme Droniou invites me to sit down at her large round dining table. I try to make small talk but have more difficulty than usual. Finally, I just blurt out, "Was this house ever number 6, avenue Marie-Thérèse?" I don't know, she says, but I'll check. She offers me some tea and crêpes. (When will she check, I wonder?) I am ravenous, but try to eat slowly. Mme Droniou opens a drawer behind her and pulls out a sheaf of paper.

"This is the history of our house," she tells me. And seconds later she says, "Why, yes, this was number 6, Marie-Thérèse."

"Is there anything there about a Marie Dufour?" I ask, my mouth full.

"Yes, there is. She was the original owner of this house."

"So, you have any paintings here by Victorine Meurent?"

She laughs; she's a nice woman. She touches my hand. "I'm so sorry . . ." We chat some more. I hesitate before I leave and she suggests some possibilities, and gets some phone numbers of former owners. She mentions that her husband is a Sunday painter and that all the former owners of the house were involved in art in some way or other. I ask if I can take some photographs.

A few days later Catherine Droniou—Mme Dro-

niou—calls me and says her husband, Patrick, would like to offer his assistance. Perhaps he imagines that Meurent was a great artist and that there are paintings to be found, or just that somebody interesting made pictures in his house just like he's doing. For whatever reason, this young man, father of three, professionally an engineer, offers to try to track down any surviving relatives of the original purchaser of the house.

Within ten days he locates the only son of the couple who purchased 6, avenue Marie Thérèse, from Marie Dufour. The man's name is André Bauman. He's seventy-three and lives in Nancy. By telephone Patrick learns that M. Bauman's mother has just died—at the age of 102—and that she and his father had indeed bought the house from Dufour. M. Bauman, himself, has a vague memory of Dufour. His grandmother, he says, lived in the house abutting Dufour's little cottage; his cousin still lives there. Bauman's parents bought the cottage from Dufour *en viager* in 1929. This meant that Dufour received a sum of money upon purchase of the house and subsequently a small stipend that would continue until her death. She would also live in the house until then. This arrangement is commonly made in France with elderly people. Cynically put, it's a wager against death for one party, for it for the other.

Bauman remembers that as a child he went over to Mlle Dufour's from time to time, running errands for his mother. His only memory is the odor. He said it smelled of old people, like a house that's been closed for a long time. He remembers no paintings. Patrick won-

ders if Dufour mightn't have sold them, considering how poor she was. (Could this in fact be the explanation of the *Bust-length Portrait of a Young Woman* that turned up at auction in 1930 signed "Victorine Meurent, student and model of Manet, posed for *Olympia*"?) "At Dufour's death," Bauman said to Patrick, "much of what was found in the house was burned. All that remained was a violin, a bookcase, and some books of no value." (Bauman couldn't have known that Meurent played the violin as well as the guitar.)

I locate the records of later owners of 6, Marie-Thérèse. I visit notaries in quaint little towns in the vicinity of Colombes, but I find nothing. Some people seem suspiciously secretive, but what can I do, beat them up, make them confess to hiding Victorine's paintings?

Well, I'm a redhead now, and people are saying, "You know, you look like Victorine."

Perhaps I do.

I don't know why, but I never wanted to consult Manet for advice; I never liked to. It's true that he was an easygoing man, but he had an easy authority to him, too, and somewhere I felt he would take over if I showed him my work. The teacher I found instead was Leroy. He was relatively unknown, in fact had spent a good part of his life buying and selling art. He was a good teacher, and painted in the kind of realist style I was

after. He was a self-contained, down-to-earth person. I always thought he was indifferent to me, and that I was even a bother to him. But a friend told me something he said to her, and it surprised me. It seems that Leroy was flattered to be my teacher. He apparently found Manet and his crowd interesting and associated me with them. So, Leroy advised me. I'd come by his studio on Mondays. I enjoyed it. He was an expert, and he left me alone. Also, it seems he liked my eyes. It's odd, I always thought I made men uneasy.

Notes

p. 3 Quoted in T. J. Clark, *The Painting of Modern Life: Paris in the Art of Manet and His Followers* (New York: Alfred A. Knopf, 1985), pp. 88, 94; and in George Heard Hamilton, *Manet and His Critics* (New York: W. W. Norton & Company, 1969), p. 71.

p. 4 Théodore Duret, *Histoire d'Édouard Manet et de son oeuvre* (Paris: H. Floury, 1902), pp. 199–200.

pp. 4–5 Emile Zola, *Édouard Manet, étude biographique et critique* (Paris: E. Dentu, 1867).

p. 5 Adolphe Tabarant, *Manet, Histoire catalographique* (Paris: Editions Montaigne, 1937), p. 73.

p. 5 Tabarant, *Manet et ses oeuvres* (Paris: Gallimard, 1947), p. 221.

p. 5 George Moore, *Memoirs of My Dead Life* (New York: Boni and Liveright, 1920), pp. 54, 55.

p. 6 Tabarant, "Celle qui fut 'l'Olympia,' " *La Bulletin de la Vie Artistique* II, 1921, p. 299.

p. 6 Georges Rivière, *Renoir et ses amis* (Paris: H. Floury, 1931), p. 32.

p. 6 Tabarant, *op. cit.* (1947), p. 346.

pp. 6–7 Paul Leclercq, *Autour de Toulouse-Lautrec* (Geneva: Cailler, 1954), pp. 54–56.

p. 7 Tabarant, *op. cit.* (1947), pp. 489–90.

pp. 10–11 Slightly paraphrased from Linda Nochlin, "Why Have There Been No Great Women Artists?" *Women, Art, and Power and Other Essays* (New York: Harper & Row, 1988 [orig. 1971]), pp. 149–50.

p. 13 Vivian Gornick, "The Next Great Moment in History Is Theirs," *Village Voice*, November 27, 1969, pp. 11, 50, 52.

p. 15 Theodore Reff, *Manet: Olympia* (New York: The Viking Press, 1977); T. J. Clark, "Olympia's Choice," *op. cit.*, pp. 79–146.

p. 22 Robert Browning, "The Bishop Orders His Tomb at Saint Praxed's Church," 1845.

p. 31 Shulamith Firestone, *The Dialectic of Sex: The Case for Feminist Revolution* (New York: William Morrow, 1970).

p. 39 *Berthe Morisot with a Bunch of Violets* is in a private collection and is dated 1872.

p. 40 Cassatt works, respectively: 1880, oil on canvas, Museum of Fine Arts, Boston; 1891, color print with drypoint, softground and aquatint, Metropolitan Museum of Art, New York.

NOTES

p. 40 Degas's *Miss Cassatt Holding Cards*, 1880–1884, oil on canvas, National Portrait Gallery, Washington, D.C.

p. 41 Bazille, *Studio on the rue de la Condamine*, 1870, Musée d'Orsay; Renoir, *Monet Painting in His Garden at Argenteuil*, 1873, Wadsworth Atheneum, Hartford; Manet, *Monet Working on His Boat in Argenteuil*, 1874, Bayerische Staatsgemäldesammlungen, Munich; Gauguin, *Portrait of Vincent van Gogh*, 1888, Rijksmuseum Vincent van Gogh, Amsterdam.

pp. 50–51 Information about Étienne Leroy found in Calvin Tomkins, *Merchants and Masterpieces: The Story of the Metropolitan Museum of Art* (New York: E. P. Dutton & Co., Inc., 1973), pp. 36–37.

pp. 51–53 This letter is located in the Adolphe Tabarant archive at The Pierpont Morgan Library, New York. MA 3950.

In the late nineteenth century, ushers, whose work included opening theater boxes for subscribers and other customers, had to pay a fee for this right. They were in effect paying rent for the seats they let to customers.

Léon Koella Leenhoff was Manet's stepson (or some say his brother-in-law), and Gustave Manet his brother.

pp. 59–60 Berthe Morisot, *The Correspondence of Berthe Morisot*, ed. Denis Rouart, trans. Betty W. Hubbard (New York: E. Weyhe, 1959), pp. 30–31.

p. 74 The Commune amounted to a civil war between the city of Paris and the French army; the national government was situated in Versailles. The Commune came on the heels of the Franco-Prussian

War and lasted from March through May 1871. France had officially surrendered to the Germans, but when an attempt was made by the French government to silence and seize the guns of Paris, fighting broke out. A bloody civil war ensued, in which more people died than during the entire Reign of Terror in the French Revolution. Women and men fought side by side, as did people of different classes. They were greatly outnumbered by the official French guard, which also had superior and more abundant weapons. The Commune capitulated and the Communards were slaughtered mercilessly. There is a wall in Père Lachaise cemetery called *"Le mur des fédérés,"* where hundreds of Communards were executed at one time.

pp. 93–94 Jean Richepin, *La Glu* (Paris: Arthème Fayard, 1881), pp. 22, 20, 18, 20, 22.

p. 100 Louise Michel, a noted feminist and socialist, was a leader during the Commune of 1871. She was one of the founders of the Association for the Rights of Women in 1870. During the Commune she worked both as a soldier and as a nurse, and was also a member of the very important Committee of Montmartre. She was one of thousands who were imprisoned on the penal island of New Caledonia after the Commune.

p. 103 Théodore Véron, *Dictionnaire Véron: Memorial de l'Art et des Artistes Contemporains, Le Salon 1879*, pp. 411–12.

p. 104 Jacques Goedorp, "La fin d'une légende: 'L'Olympia' n'était pas montmartroise," *Le journal de*

l'amateur d'art, Feb. 10–25, 1967, p. 7, and March 10–25, 1967, p. 7.

p. 104 This article was written by Adolphe Tabarant and published in *L'Oeuvre*, July 10, 1932, p. 1.

pp. 112–113 Sigmund Freud, *Dora: An Analysis of a Case of Hysteria* (New York: Collier Books, 1963), p. 37.

p. 113 *Ibid.*, p. 42.

p. 114 *Ibid.*, p. 115.

p. 114 *Ibid.*, pp. 125–26. For a fascinating compendium of commentary on the Dora case, see Charles Bernheimer and Claire Kahane, eds., *In Dora's Case: Freud, Hysteria, Feminism* (New York: Columbia University Press, 1985).

pp. 119–120 Marie-Hélène Fau-Virally; received May 1991.

pp. 143–144 Quoted from Mina Curtiss Papers, Sophia Smith Collection, Smith College, Northampton, Massachusetts.

p. 150 Tabarant, "Celle qui fut l'*Olympia* de Manet," unpublished manuscript (1949), p. 39.

p. 150 *Ibid.*, p. 10.

p. 150 *Ibid.*, pp. 42–43.

pp. 150–151 *Ibid.*, p. 53.

p. 151 *Ibid.*, p. 73. Louis Gauthier-Lathuille was the son of the restaurateur Père Lathuille, about whose restaurant Manet had made his memorable painting *Chez le Père Lathuille*, now in the Museum of Fine Arts, Tournai.

p. 151	*Ibid.*, pp. 60, 70.
pp. 151–152	*Ibid.*, p. 41.
p. 152	*Ibid.*, pp. 83–84.
p. 152	*Ibid.*, p. 61.
pp. 152–153	*Ibid.*, p. 65.
p. 153	*Ibid.*, pp. 78–79.
pp. 153–154	*Ibid.*, p. 83.
p. 154–155	*Ibid.*, pp. 78–79.
p. 157–158	Letter from Otto Friedrich to the author, August 16, 1988. Mr. Friedrich has since published *Olympia: Paris in the Age of Manet* (New York: HarperCollins, 1992).
p. 158	Margaret Mary Armbrust Seibert, "A Biography of Victorine-Louise Meurent and Her Role in the Art of Édouard Manet," Ph.D. diss., Ohio State University, 1986.
p. 164	I am grateful to Ms. Catherine Fehrer for information about the Académie Julian.
p. 168	Colette, *The Pure and the Impure*, trans. Herma Briffault (New York: Farrar, Straus and Giroux, 1980 [orig. 1932]), pp. 99, 101.
p. 169	Colette, *The Vagabond*, trans. Enid McLeod (New York: Ballantine Books, 1989 [orig. 1911]), pp. 177–78.